3 4028 06588 1816
HARRIS COUNTY PUBLIC LIBRARY

976.4 B
Barker,
A Texas journey : the
centennial photographs of
Polly Smith

W9-DFV-036

$49.95
ocn181603433
06/06/2008

DISCARD

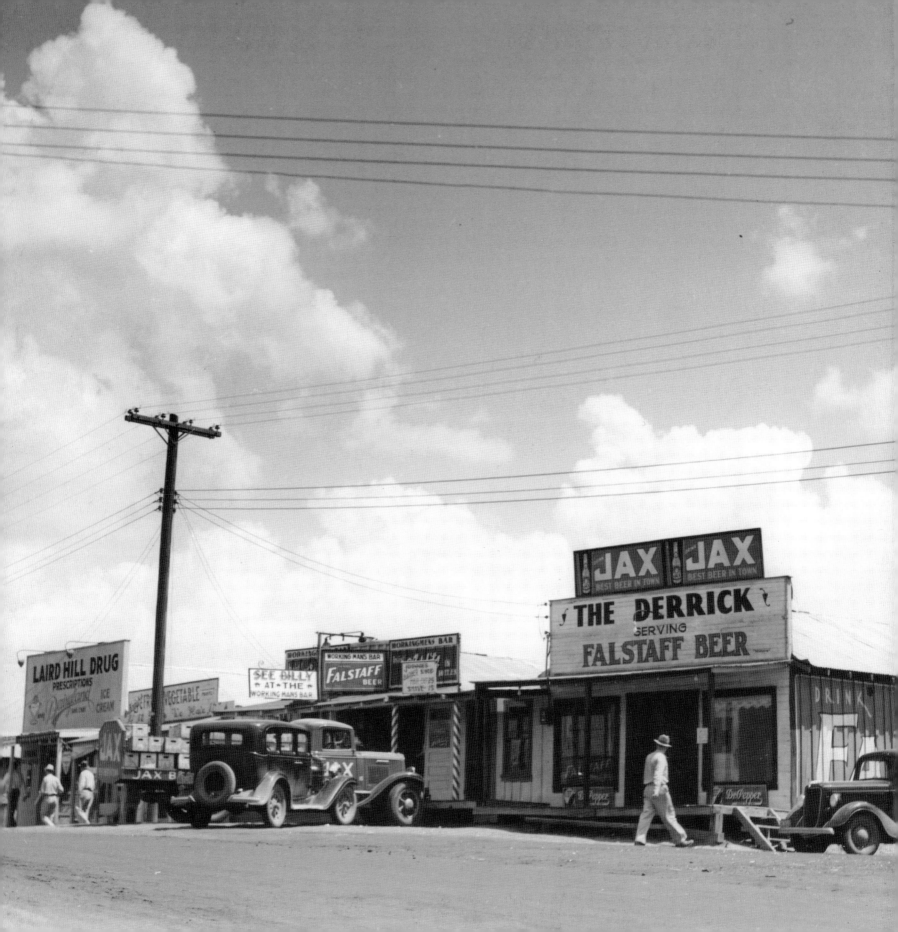

A TEXAS JOURNEY

THE CENTENNIAL PHOTOGRAPHS OF POLLY SMITH

BY EVELYN BARKER

A TEXAS JOURNEY

THE CENTENNIAL PHOTOGRAPHS OF POLLY SMITH

BY EVELYN BARKER

Copyright © 2008
Dallas Historical Society, Dallas, Texas
All rights reserved including the rights of reproduction or transmission in any form.

Published in the United States
by the Dallas Historical Society

Cataloging-in-Publication data will be held on file with the Library of Congress.

ISBN-13: 978-0-980055702
ISBN-10: 0-9800213-0-8

Book Design Buell Design, Dallas, Texas

DEDICATION For Gail, with love

ACKNOWLEDGEMENTS

First, I'd like to thank my husband Robert for all of his support, patience, and love during this project. Bob, I could not have done this without you and I love you always. Also, my sons Will and Scott were very patient, and I am grateful for their love, sweetness, and help typing. Thanks, too, to my mother Betty White for her unfailing belief in me and her love and support.

Although I have spent my whole life in libraries, I came to appreciate them in a new way while writing this book. Libraries preserve our past. They preserve the past of the everyday person and, more importantly, make that past available to us. Their worth is beyond any measurement. The staff of the Dallas Historical Society have made this job such a pleasure. Thank you to Michael Duty for believing in this project and working to make it happen. Thanks, too, to Susan Richards and Rachel Roberts for their knowledge of the Centennial collections and their constant help. Thanks to Mike Hazel for his thoughtful editorial help and Jon Buell for his strong vision of this book.

The resources and staff of the University of Texas at Arlington Library are extraordinary. I'd like to particularly thank the tireless Interlibrary Loan staff, who often amazed me with what they could get. I'd also like to thank the Special Collections library, with its wealth of Texas resources, and Mary Jo Lyons and Gerald Saxon for their interest and encouragement.

Other libraries I'd like to thank are: McDermott Library Special Collections, University of Texas at Dallas; Institute of Texan Cultures, University of Texas at San Antonio (Patrick Lemelle); Dallas Public Library (Carol Roark); Center for American History, University of Texas; Austin History Center; Texas State Library and Archives; the Texas Collection, Baylor University (Ellen Brown); Stephen F. Austin High School in Austin (Angie Reeve); Texas State Preservation Board (Victor Hotho); Library of Congress (Maja Keech); and Princeton University Art Museum (Joel Smith).

Many people helped me to write this book, and I am grateful for all their time and expertise. Particular people I'd like to thank are: Leisa Lees for putting me on the right path with Polly's life; Diane Balay for her interest in Smith family history; Hortense Sanger for putting me in touch with Gail Muskavitch; Suzanne Huffman at Texas Christian University for generously sharing her work on Gail Muskavitch; Advent Lutheran Church in Arlington, Texas, for showing me what was possible in this work; Billy Bob Hill at Collin County Community College for his help with the poems; Ed Seay, Sr., and Ed Seay, Jr., of MAL Hobby in Irving, Texas, for sharing memories of the Dallas Aviation School and saving slides that Polly took; Rene West at the University of Texas at Arlington for helping me to identify Polly's camera; Bill Green at Panhandle Plains Historical Museum for generously sharing his work on A.A. Burck; Alma Nabham at the University of Texas for assisting me with Polly's career as a student there;
(Continued on next page)

Darwin Payne for his encouragement; Ron Gardner and Nancy Larson for being such good friends; and, most especially, Gaylon Polatti for finding Polly's photos in the first place and locating the early information about her in the DHS Centennial collection—I owe you a debt of gratitude.

Lastly, I want to recognize the contributions of Polly's family. Thank you to Peter and Chris Prichard for being so kind, supportive, and generous with your memories of Polly. Thank you, too, to Deborah Smith for her help in filling in some gaps concerning her father. To my friend Carla Smith, how can I ever thank you for your abounding kindness and hospitality? Through you, I got to know Polly as a person and not just as a photographer.

No amount of thank-yous in the world would be enough for Gail Muskavitch, Polly's sister. Gail, your love for Polly has been my inspiration, and you'll never know the joy I've had in bringing Polly's story back into the light. Thank you for sharing your sister and your family with me. It's been an honor.

— Evelyn Barker

TABLE OF CONTENTS

BEAUTIFUL TEXAS

You have all read the beautiful story
Of countries far over the sea,
From whence came our ancestors
To establish this home of the free.
There are some folks who still like to travel
To see what they have over there,
But when they go look, it's not like the book
And they find there is none to compare.
To beautiful, beautiful Texas,
Where the beautiful bluebonnets grow,
We are proud of our forefathers
Who fought at the Alamo.
You can live on the plain or the mountains,
Or down where the sea breezes blow,
And you are still in beautiful Texas
The most beautiful place that I know.

— W. Lee O'Daniel, 1939

A PRAYER FOR TEXAS

May Texas write her name against the skies

As splendidly as she has done before;

Her lone star burning—her six flags unfurled,

Her voice, a call of welcome to the world.

— *Grace Noll Crowell, 1936*

It was a pleasantly warm day in San Antonio. The sun shone brightly through fluffy clouds that dotted the autumn sky. Polly Smith, 27, held her Graflex 5x7 camera against her chest and pulled out the dark slide that covered the film in the holder. She looked down through the focusing hood and adjusted the image she saw of a young man holding his guitar and wearing a broad sombrero. She gently thumbed the shutter release lever,[1] capturing the image on film. Then Polly replaced the dark slide and flipped the film holder over,[2] readying the camera for the next shot. She asked the man to move near a rose window and strike a similar pose. He did, and she captured that image, too. They continued to try different poses and locations until Polly felt she had what she needed.

Working as a photographer for the 1936 Texas Centennial Central Exposition, Polly's stop in San Antonio was one of many. She had been hired by the Exposition to do something unprecedented: to travel across the state and assemble "an adequate and complete file of representative Texas photographs."[3] Never in the history of this great state had anyone made a photographic survey of it. Now, with the hope of travelers from across the country coming to the Centennial Exposition, organizers needed enticing photos—lots of them.

THE CENTENNIAL TAKES ROOT

The movement to celebrate the centennial anniversary of Texas' independence from Mexico got its start in 1923 at Corsicana. Speaking on the topic "What Texas has to advertise and how to advertise it," Theodore H. Price—a financial editor from New York, of all places—suggested to the Advertising Clubs of Texas and the Texas Press Association that the state should produce an international exposition like the Columbian Exposition in Chicago (1893) and the Louisiana Purchase Exposition in St. Louis (1904).

He summarized the array of Texas products that could be promoted, then turned to his main point: "But you have something else whose value and whose appeal I doubt whether you yourselves appreciate. It is your gloriously romantic history." Price spoke ardently of attracting tourism and showcasing industry, and, when he finished, his audience erupted into cheers.[4]

The state's newspapers enthusiastically endorsed the idea, and Price hired Texan William H. Kittrell to send everything printed on the proposal to him in New York.[5] Kittrell did so and, presciently, continued to monitor the clippings through the years, even as the Centennial movement languished in the late 1920s, then threatened to expire under the woes of the Great Depression.

TEXAS DURING THE DEPRESSION

Initially, Texas wasn't too concerned about the Great Depression. In 1931 the *Taylor Daily Press* crowed:

> Depressions come and go. Industrial centers and large cities that depend on industry alone for wealth change overnight from prosperity to poverty and from happiness to misery—but not so with Taylor and communities that live as God intended man to live—FROM THE PRODUCTS OF THE SOIL! (Emphasis theirs.)[6]

Dust storm approaching in Dalhart, Texas, February 21, 1935

Courtesy Fort Worth Star-Telegram *Collection, Special Collection, The University of Texas at Arlington Library, Arlington, Texas*

Unfortunately, the drought of the 1930s made the soil spectacularly unproductive. Although droughts happened from time to time, the dust storms that accompanied the drought in the 1930s were a new menace.[7] The storms affected all of Texas, reaching south to the Rio Grande Valley and the Gulf Coast.

Dust hung in the air, blocking the sun and halting air traffic. Outdoor animals suffocated. People wore cloth masks to avoid breathing dust and feared "dust pneumonia." The storms were so terrible and catastrophic that

some believed they were God's punishment on the country: "Jehovah will make the rain of thy land powder and dust; from Heaven shall it come down upon thee, until thou be destroyed."[8]

Although slower to reach Texas than other parts of the U.S., the country's economic woes took their toll, too. Banks failed and businesses closed. Prices on cotton, still an economic mainstay of the state, dropped precipitously. In urban areas, salaries were cut or not paid at all. Local charities and governments took up the burden of providing for those less fortunate.

CENTENNIAL REVIVAL

Fred Florence

It was with these troubles pressing on the state that the Texas Legislature finally took up the cause of the Centennial and, after much delay, passed a bill in 1934 that said a Centennial celebration would occur in 1936. With confirmation at last, the immediate concern was to choose a host city for the celebration and related exposition. From the start, Dallas was determined to be that city. The expected rewards were increased revenue, population growth, and cultural cachet—all things that could only help a struggling economy. Fred Florence, Dallas Chamber of Commerce Centennial Committee chairman, succinctly stated the view of Dallas' business leaders when he said, "This is the greatest opportunity that has been offered Dallas in its history."[9]

But Dallas had competition. San Antonio, as the state's oldest city (founded in the 1700s), argued long and hard for a patriotic and historic celebration not tainted by crass commercialism. Houston, site of the Battle of San Jacinto where Texas won its independence, felt that its future as a leading city in the state depended on landing the Centennial. Dallas, as was often noted, didn't even exist in 1836, but felt that it best represented the progressive Texas of the future.[10]

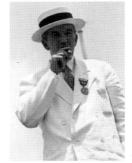

R.L. Thornton

On September 6, 1934, Dallas Chamber of Commerce leaders hosted 21 members of the Texas Centennial Commission at the city's elegant Baker Hotel and impressed upon them the advantages Dallas offered as the site of the exposition. Nathan Adams cited the city's 46 years of experience in staging the State Fair of Texas as excellent practice for the exposition. R.L. Thornton remarked that Dallas was a major transportation hub for rail, air, and roads. Architect George Dahl showed drawings of how the state fair grounds could be remade for the exposition.[11]

Then came the real test of Dallas' commitment. In his book *The Year America Discovered Texas*, Kenneth Ragsdale wrote that Texas Centennial Commission member Walter Cline asked if Dallas would hold the exposition even without state or federal funds. Thornton replied, "Dallas has already said 'Yes.'"[12] When asked the same question, Houston and San Antonio said "No." The strong words and strong leadership of Dallas assured its selection.

At 4:30 p.m. on September 9, 1934, Centennial Commission Chairman Cullen F. Thomas stepped out at Austin's glamorous Driskill Hotel and announced Dallas as the winner.[13] City leaders rejoiced, but the Centennial year was only 16 months away and, despite Thornton's words to the contrary, Dallas needed state and federal funds to put on a show that would attract national attention. To secure funding, former Texas Lieutenant Governor Edgar Witt began to lobby the Legislature. He was helped by William H. Kittrell, who had continued to follow the saga of the Centennial since 1923.

William H. Kittrell

From the collections of the Texas/Dallas History and Archives Division, Dallas Public Library

Kittrell was born on April 29, 1894, in Alexander, Texas. As a young man, Kittrell worked as a reporter for the *Cisco Roundup* and the *Cisco Apert*, then started working with the Texas Press Clipping Bureau. He had a natural curiosity and a quick mind that retained names, faces, and information. These attributes, combined with an encyclopedic knowledge of current Texas affairs, led Kittrell into Democratic politics, where he quickly took a leading role:[14] in 1924, he helped to elect Barry Miller as Lieutenant Governor; in 1930, he directed the successful campaign of Edgar Witt, also for Lieutenant Governor; and in 1932, he was the assistant secretary to the National Democratic Convention in Chicago.[15]

By 1934, Kittrell was known as "the man who could get past the appointment clerks and put the matters at hand before legislators and officials through whose votes or instructions federal or state action must come."[16] Witt and Kittrell lobbied hard for state funding of the Centennial Exposition, and their efforts paid off when Governor James Allred signed the Centennial appropriation bill on May 7, 1935. State funding assured, Kittrell hastened to Washington, D.C., to lobby for federal funds. In Dallas, architects and workers immediately began the huge job of transforming the city's state fair grounds, Fair Park, into a site fit for a world exposition.

MARKETING THE CENTENNIAL

Besides building an exposition, Centennial staff had to promote one, too, and there was only 13 months left. By contrast, Chicago's popular 1933 Century of Progress exposition had 10 people working on promotion five years before it opened.[17] Frank Watson, director of the Centennial Exposition's Promotion Department, was acutely aware of the challenges ahead when he wrote:

Only by careful planning, accurate timing, expert operation and intensive effort could we hope to overcome the handicap imposed by the Exposition schedule; and in twelve months time sell the Exposition, Dallas and Texas to the entire nation.[18]

Centennial leaders struggled to balance a historical celebration with a commercial enterprise. Although some turned up their noses at what they saw as the over-commercialization of a great historic event, Watson and his team deliberately used the historic and romantic angle as a lure. They had three goals: to promote the state's colorful western image and heroic past; to attract new business and industry to the state; and to attract tourists to the Exposition.[19] Key to the promotion plan was the use of photographs, but here they ran into a major difficulty: no one had ever photographed Texas for publicity purposes.[20] This meant that there was not a source of photographs suitable for sending to the magazines and newspapers that might run stories about the Centennial; there were no shots that could be sent to tourism outlets; there was little even to illustrate the Exposition's own brochures and pamphlets.

Fair Park in 1934 before Centennial Exposition construction

The press and periodical divisions of the Exposition's Promotion Department had been busy writing press releases and submitting story ideas, but the lack of photographs hampered further efforts. Watson wrote, "One hundred twenty additional articles for trade magazines are now on hand ready to mail as soon as proper photographic illustrations can be assembled."[21] Here again, William Kittrell, now the Exposition's assistant to the general manager, stepped in. He knew someone who could help: Polly Smith, a talented young photographer from Austin. Polly would fill the state's photographic gap and illustrate Texas for Americans.

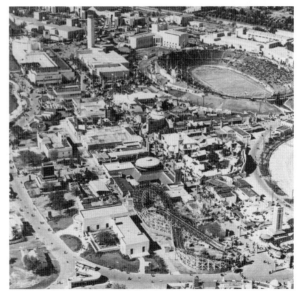

Fair Park in 1936

THE OLD OAK SPEAKS

My roots are buried deep in Texas ground.

I grip the harder when the great winds blow.

— *Margaret Bell Houston, 1926*

PIONEER BEGINNINGS

Polly Smith's upbringing and innate characteristics provided her with the perfect skills to work as a traveling photographer for the Texas Centennial Exposition. A middle child in a family of seven children, Polly wandered through much of central and northern Texas with her family as her father sought new and better job opportunities. Because they never stayed in one town more than a few years, the children developed "quiet courage"[1] in response to change and formed a close bond among themselves that lasted all their lives.

Fortunately for them, the Smith children had Marion (Minnie) Burck Smith as their mother. Minnie taught all her children self-reliance and the importance of working together to get through life's tough times. Of their mother, Polly's eldest sister, Dorothy Smith Walton, wrote, "Our admiration for her is unbounded."[2] Polly said, more simply, "Boy, what a woman."[3]

Besides learning self-reliance from Minnie, Polly inherited ambition and tenacity from her pioneer grandparents and great-grandparents who came to settle in Texas. "In my humble judgment," Polly's eldest brother, C.R. Smith, wrote, "there is nothing our country and the world needs more than the fundamental moral fiber of the Texas pioneer. . . . They were not looking for security; they were looking for an opportunity to 'get started.' Texas, to them, was not to be a land of rest, but a land of challenge."[4]

Certainly, Polly's ancestors found opportunities and challenges when they came to the state in the 1800s. On her mother's side, Polly's family could trace its Texas roots to the Republic era. Her maternal great-grandparents had emigrated from Germany in 1836 and settled in Galveston in 1839. Their son, Alfred Andrew Burck, was born on April 23, 1846. Burck was an educated and ambitious man. At 22, he worked in a bookstore in Bryan, Texas,[5] but, upon learning that the International & Great Northern Railroad was coming through nearby Milam County, he packed up his wife, Frances, and infant daughter, Marion, and moved in search of better fortunes. They settled in the Milam County community that would become Rockdale.

Alfred Andrew Burck

Courtesy of the State Preservation Board, Austin, Texas; A.A. Burck; P1-25A; from Senate composite of 18th Legislature; ID 1989.582

In its early years, Rockdale perfectly depicted a stereotypical Wild West settlement. Newspapers recorded daily street fights, corrupt police, and con artists preying on the innocent.[6] The *Galveston Weekly News* reported that Rockdale would "vie with almost any other railroad town as a den for gamblers."[7] Undeterred, Burck and his growing family stayed. When the town incorporated in 1874, he became its first mayor, a position he held until 1881.[8]

Being mayor of this rough and rowdy town demanded courage and strength of character. Within months of taking office, he narrowly escaped death when the town marshal attempted to subdue a prisoner by striking him over the head with a six-shooter. The gun went off, grazing Burck in the neck.[9] Less than a year later, Burck threatened to call in the state militia to keep order after he heard that Rockdale citizens had formed a "vigilance committee" to deal justice to the gamblers plaguing the town.[10]

However, Burck and the townspeople persevered in their efforts to civilize Rockdale, and by 1884 they could claim progress. Although the streets were dirt, the town offered kerosene lamps to light the wooden sidewalks at night, two schools, five churches, and a 250-seat opera house.[11] Alfred Burck was ready for a new challenge.

BUILDING THE STATE CAPITOL

In 1881, the Texas Legislature focused on building a new state capitol, as the existing one, completed in 1853, was considered inadequate for the needs of the growing state. The Capitol Board approved the design of a new building in May, then solicited bids from contractors to supply the building materials and complete "every class of work required."[12] The winning contractor would receive no money from the cash-strapped state, but would receive 3 million acres of land in the Texas Panhandle.[13]

Texas capitol in Austin

The Board received only two bids by the deadline of January 1, 1882, and Alfred Burck's was one. Burck was backed by a group from Chicago,[14] although how he arranged this is unclear; however, Mathias Schnell of Rock Island, Illinois, had the lower bid and the Board chose him to build what would ultimately become one of the most spectacular state capitols in the country. When it opened in 1888, *The Dallas Morning News* wrote, "All Austin has poured into the mammoth structure, women, men, children and many dogs. And yet there is plenty of room left for a base ball field."[15]

Possibly as a consolation prize, Burck was named sergeant-at-arms for the Texas senate in 1883, but a rift developed between him and his wife. By the time his daughter Marion was 15, Burck had left his family and moved to Houston to work as a traveling salesman for the *Houston Post*. His wife, Frances, styled herself a widow and started trying to make ends meet for herself and her four children.

Marion made the logical choice for smart young women of the day and became a teacher. Teacher certification was a relatively informal affair: the applicant appeared before the certification board and answered questions about a variety of topics until the board was satisfied that the applicant was a competent teacher.[16] Marion was tireless, caring, and much beloved by her students, leaving them with an indelible impression. Nearly 30 years after she left the classroom, a former student admiringly recalled her by saying, "She has a habit of making good."[17]

Marion had been fond of her father and wrote to him for 10 years after he left, saving all his letters in return.[18] Their connection was lost when rumors of riches induced Alfred Burck to join the Klondike gold rush in the late 1890s. Burck eventually returned from Alaska without striking gold and settled in California, but he never corresponded with Marion again.[19] She thought he had perished in the Klondike. Alfred Burck died in California in 1908.[20]

Marion Burck

Private Collection

Difficult as losing her father and helping to support her family must have been, Marion's experiences were crucial to her later as she dealt with her own troubles. The hardships she faced as a girl didn't embitter her; rather, they strengthened her for what was to come.

CIVIL WAR VETERAN

Polly's father, Roy Egerton Smith, also had a challenging childhood. His father, Cyrus Riley Smith, was a farm boy, born in Georgia[21] on August 13, 1837. Cyrus Riley received a solid education and worked as a teacher before deciding to read law. He interrupted his career to join the Confederate Army as a private in 1861, and ended the war as second lieutenant in the Alabama Cavalry.[22] After the war, Cyrus Riley

married Cornelia Orr and moved to Cameron, Texas, to practice law. He and his wife lived on a 12-acre estate in Cameron[23] with their four children, the oldest being Roy, born on April 27, 1869. Cyrus Riley Smith was well-respected and represented Milam County at the pivotal 1875 Texas Constitutional Convention, which sought to undo many Reconstruction policies.[24] When Roy was 9, Cyrus Riley suffered a nervous collapse, caused, it was said, by overwork in the Legislature. He was committed to the State Lunatic Asylum in Austin,[25] where he remained until his death in 1916.[26] Cornelia, calling herself a widow, moved the family from Cameron to Salado to be closer to him.[27] Later, as a young man, Roy left Salado and returned to Milam County. He settled on a farm between Cameron and Rockdale.[28]

MARRIAGE

By the 1890s, Rockdale was a bustling railroad center. Roy probably traveled there to buy supplies or ship his farm goods, and somehow he met the lovely young teacher Marion Burck. They had a lot in common: they were both well-educated and came from prominent local families. Both of them had absent fathers who had been involved in politics.

They married the day after Christmas, 1893,[29] but it soon became clear that their commonalities could not overcome their differences. For example, Roy could never settle on a job. Roy and Marion moved all over Texas while Roy tried jobs in farming or sales.

Their first child, Dorothy, was born in Waco in 1898 while Roy worked as salesman for the *Waco Times-Herald*.[30] The Smiths soon moved to a farm in Minerva where their second child, Cyrus Rowlett (C.R.), was born in 1899. In 1904, the Smiths were living in Oak Cliff outside of Dallas. Their third child, Mildred (Gail), was born while Roy worked for *The Dallas Morning News* in the circulation department.[31]

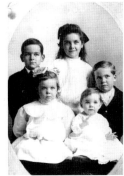

Polly Smith, infant, circa 1909

Private Collection

After Dallas, the growing family moved to Ruston, Louisiana, where Frances Sutah (Polly) was born on December 29, 1907. Two years later they were in Blum, Texas, where Carruth (Bill) was born. Roy, who was now selling insurance, was already planning to move the family to Amarillo, and their son Burck was born there in 1911. By 1913 they had settled in Whitney, Texas, where Marion's brother Robert lived. Roy and Marion's last child, Floris (Flo) was born in Whitney on March 31, 1913.

MINNIE AND HER SEVEN

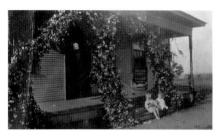

Smith home in Whitney, Texas. Pictured are Burck and Flo Smith.

Private Collection

Whitney, like Rockdale, was a railroad boomtown. Cotton was its primary industry, and the Smiths lived next to a large cotton farm. To earn extra money, the children picked cotton for a penny per pound.[32] Their home was small for such a large family, but it had a long front porch with honeysuckle vines growing on it and an all-too-clear view of the neighbor's large black bull staring at them over the fence.[33] It was in Whitney that Marion acquired the name she would henceforth be known as: When one of the children tried to pronounce Marion's name, it came out "Minnie," and the name stuck. For the rest of her life, her children and friends called her Minnie.

In 1916, Roy's father, Cyrus Riley Smith, died. Although he had lived apart from his family for many years, his death may have led to Roy's next actions. Perhaps initially planning to settle some business relating to his father's death, Roy took a train out of Whitney.[34] He never returned.

Roy and Minnie exchanged letters for a time. Minnie cried when she read the letters, but she never shared the contents of them with her children.[35] Finally, it became clear to Minnie that, like her own mother before her, she was on her own. Now she had to tell her children.

Smith family. Pictured left to right: Bill, Polly, Dorothy, C.R., Minnie, Flo, Gail, and Burck.

Private Collection

She gathered them around the dining table and said that their father would not be coming back, but that they would be all right. Dorothy Smith Walton recalled, "She said in essence, 'We have each other, we love each other, we must help each other always and we will get along.'"[36] Minnie followed the examples of her mother and mother-in-law and called herself a widow from this point on.

Roy's disappearance from his family's life was complete, although he did keep in touch with his own sisters, who in turn corresponded with the Smith children. His sisters didn't talk about him to their own children, and his mother's 1931 obituary didn't include him, although it listed Minnie as a daughter.[37] It's not known what Roy did after 1916; he spent the last 15 years of his life in a nursing home in Lakeland, Florida, after retiring from his job as a Salvation Army hotel manager. He died January 11, 1956.

Minnie, meanwhile, handled her misfortune with courage, dignity, determination, and a positive attitude. After Roy left, Minnie's brother, Robert, stepped in to help the family move from Whitney to the larger town of

Hillsboro.[38] In Hillsboro, "there were lights in the streets and you could see at night," Gail recalled.[39] It was a fresh start for the Smith family, which now comprised Minnie and "her seven."

As when her own father left, Minnie's immediate concern was earning a living for her family. First, she sold long, lace-up corsets door to door, but corsets were quickly losing popularity with the changing fashions. Next, Minnie sold the *Encyclopedia Britannica*.[40] She walked the neighborhoods of Hillsboro with her samples and used her teaching background to help make the sale. All the walking led to a painful bunion on her foot. "Her foot hurt so badly that she would ask me to take her shoe off of her foot. And I would slowly take off the shoe so that it wouldn't hurt her foot," said Gail.[41] But Minnie carried on. Even with money scarce and a toilsome job, she never lost courage and always presented a smiling face to her children.

THE 14TH CENSUS

Despite the demands of her job and family, Minnie, aided by family connections, found time to be an active supporter of the Democratic Party. In 1919, America was preparing for the 14th census, and competition for the district census supervisor positions was strong. The U.S. Secretary of Commerce appointed supervisors based on the recommendation of the Director of the Census. The Director made his recommendations from the opinions of those closer to the actual district, usually local politicians.

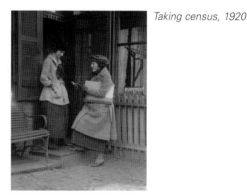

Taking census, 1920

Library of Congress Prints and Photographs Division, Washington, D.C.

In Minnie's case, U.S. Representative Rufus Hardy of Corsicana recommended her as County Census Supervisor for the 6th district,[42] which encompassed Hill, Milam, Robertson, Brazos, Freestone, Limestone, and Navarro counties.[43] Out of 372 census supervisors in the nation, she was one of only four women to hold that position in 1920.

Being a census supervisor was no figurehead position. First, Minnie needed to hire about 200 census enumerators[44] for the district. To become an enumerator, a person applied to the supervisor. After receiving the application, the supervisor would mail the applicant a blank enumeration schedule and other documents. The applicant would study these, then report to a public building, usually a school, to take a proctored exam. The exam consisted of a narrative description of several families. The applicant filled out a sample schedule based on the information in the narrative, then gave the exam to the supervisor for grading. The supervisor sent the graded exams to the Census Bureau for review, and the bureau notified the supervisor who could be hired.[45]

Across the country, supervisors of the 14th Census had difficulty finding enough applicants, and scrambled to fill the positions. Part of the problem was the temporary nature of the enumerator's job. The census was taken in a two-week period, with four weeks allowed for rural areas. After that, the enumerator's job was finished. Low

pay—a frequent complaint—also discouraged applicants. The pay rate was set by law, and enumerators in non-rural areas earned two-to-three cents for each name they gathered.

In Texas, hundreds of enumerators were needed for each district, but by October 1919 only dozens had applied. From Falls County, *The Dallas Morning News* reported, "Many believe the work is not offering the proper compensation in keeping with present conditions, the high cost of living."[46] In Dallas, only 40 people had applied to fill 150 positions.[47] The supervisor in Wichita Falls resorted to enlisting the help of the local Chamber of Commerce to conduct the census because of "the difficulty in obtaining enumerators at the pay offered by the government."[48] As the census start date drew closer, desperation forced the federal government to raise the rate to four cents per name.[49]

Supervisor pay was more generous. Supervisors earned a base pay of $1,500 and $1 for each 1,000 names enumerated, bringing the average total to $1,800.[50] As the 1920 U.S. Census would show, the average annual income for men in 1919 was $1,354.

The Census Bureau in Washington, D.C., sent tons of blank forms to the supervisors and a "well-made wooden box,"[51] in which the supervisors returned the completed forms and documents. Minnie mailed the blank forms to her enumerators and trained them for the task ahead.

In addition to the enumerators, Minnie also supervised an inspector and a large clerical staff, which included her daughter Dorothy. Inspectors acted as deputy supervisors in the field and met with enumerators to inspect their work and answer questions. The clerical staff aided the supervisor in tabulating the data brought in by the enumerators.

On January 2, 1920, the census began. The next four weeks would be nonstop for Minnie. Often, she wouldn't even leave her office at the Hill County Courthouse to travel the mile home for dinner. Instead, she brought a pot from home and used Sterno to heat her food.[52]

The job showcased Minnie's abilities as a manager and her "considerable tact, intelligence and knowledge of business."[53] Rufus Hardy was certainly pleased with her job performance, and wrote to Governor-Elect Pat Neff, "She made perhaps the most efficient record of any of the supervisors of the state. She was very highly complimented by the Census Bureau at Washington."[54]

This success led immediately to her next job as special agent for the industrial census. Her territory included Tarrant, Hill, Johnson, Navarro, McLennan, Limestone, Bell, and Falls counties. Here, too, Minnie garnered acclamations like "unusual executive capacity, tireless industry, and extremely conscientious attention to every responsibility."[55]

The City of Fort Worth was so impressed with her that they asked her to work with the Fort Worth Chamber of Commerce to designate the city as a port of entry for goods. At the time, Dallas was a port of entry, but Fort Worth was not. That meant that foreign merchandise ordered by a merchant in Fort Worth would arrive in Dallas and stay there until the Fort Worth buyer learned of its arrival and sent the import duty money.[56] Minnie accepted the job, and Fort Worth soon got its designation.

Governor Pat Neff

From the collections of the Texas/Dallas History and Archives Division, Dallas Public Library

During this busy time, Minnie continued her political activism. In 1920, she enlisted the help of her youngest son, Burck, to put up campaign posters for gubernatorial candidate Pat Neff. Neff, from nearby McLennan County, was running against Joseph Weldon Bailey, a known adversary of woman suffrage. Minnie had actively supported woman suffrage for years, and, for her, the choice was clear.

Neff and Minnie must have met during his campaign, as several letters from prominent men to Neff refer to their "mutual good friend" Mrs. Roy E. Smith.[57] After Neff's election, Minnie applied for and received a job in state government. The family moved to Austin in 1921.

AUSTIN

She leans upon her violet hills at ease

At the plains' edge: innocent and secure,

Keeper of sacred fountains, quaintly sure,

Greek draperies fluttering in the prairie-breeze.

— Karle Wilson Baker, 1929
From Some Towns of Texas

Smith home on
Rio Grande Street
in Austin

Private Collection

For the first time, Minnie and her seven would stay in one town long enough to consider it a real home. They settled in a two-story frame house on Rio Grande, a pretty tree-lined street with streetcar tracks running down the middle. As a teenager, Minnie had helped her family financially by teaching school. Now she encouraged her children to work and contribute the money to a general fund for the benefit of all. Child workers were not uncommon in the 1920s, but often their income came at the expense of their education. This would not be the case for Minnie's children.

All seven children, even the youngest, helped out. While the family was living in Whitney, Dorothy had attended the College of Industrial Arts in Denton (later Texas Woman's University). After returning home, she began sewing on a machine her aunt had given her. She turned out to be a talented designer and dressmaker, so she opened a shop in Austin close to several sorority houses.[1]

C.R., who had worked as a bookkeeper at Hillsboro's cotton mill, enrolled at the University of Texas to study business administration. At the same time, he held a part-time job at the Federal Reserve Bank and ran his own advertising agency called C.R. Smith and Co.[2]

The younger Smith children attended Austin public schools and worked. Again, Minnie's political connections came into play. Polly's brother, Burck Smith, recalled how in 1923 he contributed to the Smith family fund:

My first job was as a page in the State Senate, where [my brother] Bill had been a page before me. Bill told me how to be a good page—running errands for the 31 members of the Senate—each senator's name—each senator's desk, . . . when to deliver newspapers to them, etc. It was an enjoyable experience, and since the legislature was in session usually only 30 to 60 days every other year, it did not conflict with my school, and the money earned went into Minnie's fund. What fun! In 1925, the next session, I got a job as a page in the House of Representatives—150 members. Fortunately for me, I was assigned as a page to a row of legislators near the Calendar Clerk's desk—and then the Calendar Clerk (Ms. Fuglar) . . . asked that the Sergeant-at-Arms assign me to be their special page to run errands only for them. As a result, as each new session of the Legislature convened, I had no difficulty in getting an appointment as their special page. For many years, while in grade school, junior high school and high school, I worked in each session of the legislature. Finally, when in high school, I had become Assistant Calendar Clerk to Gladys Nichols after Ms. Fuglar had retired. Wow! I was making more money than my Manual Arts teacher in high school! At least, that's what he told me when I told him what I was making.[3]

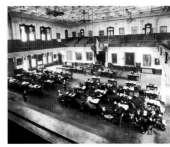

Texas Senate chamber, 1925

From the collections of the Texas/Dallas History and Archives Division, Dallas Public Library

POLLY'S EDUCATION

Polly graduated from Austin High School in 1925, having belonged to both the Choral Club and the Margaret Preston Literary Society.[4] She also found time to teach Sunday school at the Baptist church.[5] In her senior year, she was elected class poet. Her senior class photo was the most dramatic of the class and suggested her artistic tendency.

A new club at Austin High may have piqued Polly's interest in photography. In 1924, the school organized a popular photography group called the Kodak Club. The school's annual, *The Comet*, reported the founding of the club:

Frances (Polly) Smith, 1925

FRANCES SMITH
POET

Austin High School Comet, *courtesy of Stephen F. Austin High School, Austin, Texas*

> In order to give all students who are interested in photography an opportunity to make a detailed study of it, the Kodak Club was organized during the Spring Term of 1924. The club, now the largest in Austin High School, grew so rapidly that it became necessary that the membership be closed.[6]

While photography may have intrigued Polly, she was not ready to take it up as more than a hobby. Instead, she took a job with the State Highway Department as a keypunch operator.[7] In the era before computers, punch cards

tracked travel statistics, expenditures, and personnel information. Keypunch operators transcribed written data to punch cards which were fed through tabulation machines. An experienced keypunch operator working on a nonelectric key punch machine could punch 200-300 cards per hour.[8]

Polly later worked with another statistical machine, the Tabulator. Tab machines read decks of punch cards, then produced a report of the results based on the data input. As Assistant Tab Machine Operator,[9] Polly spent most of her time "sorting card decks and providing the hundreds of different card types used."[10] She even may have wired some of the boards used to "program" the tab machines.

While a job with the State Highway Department might have seemed like a safe bet during the Depression, Polly had other dreams in mind—something more creative. She admired her sister Dorothy's sewing ability and, in fall 1929, took her first class at the University of Texas (UT) in design. She earned a B in the class and signed up for a second design class in the spring, but withdrew from the university before the semester ended.[11]

In 1931 she tried writing, taking courses in composition and reporting.[12] This was the same career path her youngest sister Flo would follow, with much success. Polly completed 12 hours of coursework before returning to the Highway Department, still undecided about a career. Her actions between 1931 and 1932 are not clear, but by 1933 Polly had decided to seriously study photography. She enrolled in two art history classes and a photography class at UT in the fall semester of 1933.

PHOTOGRAPHY WITH JOHN MATTHIAS KUEHNE

John Matthias Kuehne, 1938

(di_03400), Prints and Photographs Collection, Center for American History, The University of Texas at Austin

Since 1908, UT had offered photography classes taught by one man, Dr. John Matthias Kuehne. Kuehne was a legend on the UT campus. He was born in 1872 to German immigrant parents living in Halletsville, Texas, and was educated at home along with his 10 brothers and sisters. Kuehne taught school for some years before enrolling at UT. He graduated Phi Beta Kappa in 1899 with a Bachelor's in physics, then earned a Master's degree from UT, before joining the faculty in 1901. He later earned his Ph.D. in physics from the University of Chicago in 1910.[13] Many accounts of Dr. Kuehne mention his striking appearance: tall with an erect carriage, a shock of white hair with a neat beard, and blue eyes twinkling with good humor.

Offering the photography class through the Physics Department was not uncommon. Texas Woman's University, San Antonio College, and the University of North Carolina are just some of the institutions known to have done likewise. Science had been quick to support the development of photography because scientists recognized

photography's potential to capture motion and phenomena imperceptible to the naked eye. Physics departments, in particular, supported photography classes because physics professors were generally well versed in optics. Photography classes taught through the science curriculum usually emphasized the technical aspects of photography, and the class at UT largely followed this model. The 1932-1933 UT College of Arts and Sciences catalog provides a description of the class:

> **223 Photography.** Pre-requisite: Physics 12; or Physics 1, Chemistry 1, and junior standing. Lectures and laboratory practice equivalent to one classroom hour a week. Laboratory fee, $2; deposit, $2. Mr. Kuehne.[14]

Polly had none of the prerequisites, but Kuehne, apparently impressed with her, allowed her to enroll in the class;[15] however, she withdrew before the semester ended and traveled to the country's photographic mecca, New York, to attend the Clarence H. White School of Photography.

PHOTOGRAPHY IN NEW YORK

Things looked a lot different in New York than they did in Austin. Located in Travis County, the Texas capital was a bright, shiny anomaly during the Great Depression as it had two steady, nonindustrialized sources of income for its citizens: state government and the University of Texas.[16] Although 1933 did see distressing unemployment, overall, the city remained optimistic about its future. Federal money flowed into Austin, prompting various building projects and a population boom.[17]

Urban scene by Polly Smith. Gelatin silver print.

Princeton University Art Museum. Clarence White School student work ui2007.2. Bruce M. White.

As the center for American finance, New York suffered both economically and psychologically. In 1933 New York had 1.25 million people on relief—18 percent of its population, compared to Travis County and 7 percent of its population on relief the same year. Nevertheless, for serious photographers, New York was the place to go. New York always had played a leading role in American photography. In 1902, Alfred Stieglitz founded the Photo-Secession group in New York with the aim of promoting photography as a fine art rather than as a technical medium. One of the early adherents to Photo-Secessionism was a self-taught photographer named Clarence H. White, a former bookkeeper from Ohio. White came to New York in 1906 and operated a portrait studio while teaching art photography at Columbia University's Teachers College.[18]

Clarence H. White, 1920

Doris Ulmann, photographer, Library of Congress, Prints and Photographs Division, LC-USZC4-9802

In 1914, he opened the Clarence H. White School of Photography in Manhattan. The school focused on art photography and incorporated art history and design into the curriculum—a unique approach from other existing photography programs.[19]

In the early years of the school, White hired notable teachers like Max Weber and Frederic W. Goudy. Weber, a painter, printmaker, and sculptor, taught art history and art appreciation at the White School.[20] Goudy taught typographic design.[21] Students attended special lectures given by the giants of American photography: Alfred Stieglitz, Paul Strand, and Edward Steichen.[22] Likewise, several of White's students would become the next generation of American photography giants: Margaret Bourke-White, Laura Gilpin, Paul Outerbridge, Jr., Anton Bruehl, and Dorthea Lange.

According to White scholar Bonnie Yochelson, White's teaching methods were inspired by those of Arthur Wesley Dow, chairman of the Art Department at Columbia Teachers College.

Dow set out design principles, such as opposition, or repetition, gave examples from the history of art, and offered exercises for the student, often asking him to make enlarged copies of the book's examples and then to draw others from nature. In much the same way, White combined specific design problems with general art appreciation in what he called the "project method," defined in a White School brochure

Abstraction by Polly Smith. Gelatin silver print.

Princeton University Art Museum. Clarence White School student work. ui2007.1. Bruce M. White.

as "a definitely graded series of technical and practical problems (which) the student is to perform under individual guidance and direction . . . supplemented and explained by lectures, demonstrations, print criticism and trips to museums."[23]

Polly's photo of pretzels is a typical example of one of these design problems assigned at the school.

White believed that photography could not only be art, but also be a way to earn a viable living. The 1920 and 1922 catalogs stated that the school "treats photography not only as a fine art with an established technique, but also as a practical art, indispensable to modern commerce and industry."[24]

Clarence H. White died in 1925, and his wife and son continued to run the school until 1942; however, without White's commitment to photography as art, the school had changed by the time Polly arrived. There was still the occasional lecture by a well-known photographer like Edward Steichen and there were still "project method" assignments, but the classes were larger and less intimate than in White's day, and the focus had shifted away from art. Kathleen Erwin noted in *Pictorialism Into Modernism*:

School catalogues following the death of Clarence Sr. ceased to mention cultivation of taste and personality, though instruction in art appreciation continued to be included as a segment of every course. From about 1933, however, course descriptions no longer reflected the integration of art and technique that was once a hallmark of the school. Photographic technique had apparently superseded design as the school's emphasis.[25]

After two years of honing her artistic instincts through training, Polly left New York and returned to Texas. No longer was photography a mere interest; when Polly returned to Austin in 1935, she started calling herself a photographer.[26]

Still Life with Hands by Polly Smith. Gelatin silver print.

Princeton University Art Museum. Clarence White School student work ui2007.3. Bruce M. White.

TEXAS

Texas,

Child of the West,

Who talks in the soft voice

Of the South, but packs a gun

On his hip.

— *William Allen Ward, 1934*

Society saw photography as an eminently suitable career for women, particularly when confined to taking photographic portraits of children or family in the home. Women could "more easily become a part of the family and [could] study the conditions of the family life more carefully,"[1] thus making better family portraits than men could. When photographing children, women were preferred because "few men have the patience necessary to photograph children well."[2]

Writing for *Ladies' Home Journal* in 1897, photographer Frances Benjamin Johnston said:

> Photography as a profession should appeal particularly to women, and in it there are great opportunities for a good-paying business. . . . The woman who makes photography profitable must have . . . good common sense, unlimited patience to carry her through endless failures, equally unlimited tact, good taste, a quick eye, a talent for detail, and a genius for hard work.[3]

Johnston conceded that this was an "appalling" list of qualifications, but added bracingly, "success is always possible,"[4] especially if the woman had photographic training.

The Clarence H. White School played a crucial role in encouraging women to pursue photography through its commitment to equal admissions. School catalogs specifically mentioned that classes were open to men and women, and of White's known students there are twice as many women as men.[5] Clarence White himself encouraged women to pursue all avenues of photography: portraiture, commercial, architectural, medical, news, and advertising.[6] Generally, however, discrimination and sexism against women photographers were common.

British Royal photographer Jabez Hughes typified the early view of women's participation when he wrote in 1873 that photography "is an occupation exactly suited to [women]; there are not great weights to carry, no arduous strain of body or mind; it is neat and clean, and is conducted indoors."[7] Jane White, wife of Clarence H. White, had a different view:

> The layman, wholly unacquainted with the physical exertion, the great skill, and the infinite patience required, is prone to view photography as a clean, light, easy vocation for women. Is the modern woman seeking light, easy work? Then she had best not go in for photography.[8]

Camera clubs, which held exhibitions and helped promote recognition for their members, often prohibited women from joining. Pat Liveright, an internationally recognized female photographer from New Jersey, was refused admittance to a New Jersey club because the male members had made it their refuge, and "they'd be darned if a female photographer was going to spoil it for them."[9] Liveright's response was to form a women's camera club that allowed men.

In Texas, women got an early start in photography. On December 12, 1843, the *Houston Star* reported that Texas had its first professional woman photographer, a Mrs. Davis.[10] By 1930, the number of woman photographers in the state had reached 360.[11]

THE VIEW OF TEXAS

Texas has long provided artists—painters, writers, filmmakers, and photographers—with inspiration. In its civilities, Texas balances between Old South charm and the laconic West. In its lifestyle, it morphs from cowboys to urban sophisticates. In business, it combines agriculture and industrialism. But in the 1930s, the Wild West image of Texas was firmly fixed in the popular imagination.

Movies in the early twentieth century constantly reinforced the myth of Texas being all cowboys, Indians, and desert. In his book *Cowboys and Cadillacs*, author Don Graham notes, "From 1921 through 1930, more films were made with Texas titles, contents, or settings than was true of any other state."[12] Favorite Texas subjects

included the Alamo and the Texas Rangers. Westerns frequently used the word "Texas" in their title to convey a certain mood, whether Texas served as the actual location or not.[13] Graham continues, "New subjects introduced in twenties movies about Texas added to the storehouse of Texas archetypes so that by the end of the silent era, by 1929, most of the major Texas movie plots had been rounded up. They included oil, cattle drives, and women."[14]

Popular literature also reinforced the Texas stereotype. Joseph Leach writes in *The Typical Texan*:

> Women over their washtubs, farmers at their plows, children, and the hundred other aspects of mundane life in Texas were nonexistent as far as [nineteenth-century novelette writers] were concerned. In their books the only Texans alive were he-men on horseback, never for long tied down by either apron strings, responsibilities, or the finer points of the law.[15]

Writers of the day tried to warn potential Centennial visitors that the reality of Texas was a little different from the movies. In 1936, Rose Lee Martin wrote for the *New York Times*, "Visitors . . . expecting to find in Texas the apotheosis of Wild West fiction, will be obliged to revise their fancies."[16] Martin noted the skyscrapers, corporate law offices, and faux-Spanish suburban mansions of Dallas, and the "innumerable small towns [that] have little to recommend them in the way of quaintness or architectural charm."[17]

But Martin diluted her point when, after thoroughly bringing the Texas myth down to size, she built it back up using every stereotype known.

> However, some few traces of the pioneer Southwest may be observed throughout Texas today: the sand-colored Stetson hats, the revolvers worn at the hip. Gambling devices flourish wherever they can succeed for a brief space in avoiding the vigilance of the [Texas] Rangers. You can still buy sandwiches of rattlesnake meat at Breckenridge Park in San Antonio. You can still plead the "hip-pocket movement" as legitimate grounds for homicide. You still hear of new oil wells brought in every day and the poor man still hopes to "strike it rich" in Texas.[18]

Centennial Exposition Promotion Department Director Frank Watson, aware of the state's popular Wild West image, saw nothing lacking in it. To get people to see the favorable reality of Texas for themselves, he planned to use the great romanticism of Texas as enticement. Leaving no doubt of his goals, Watson wanted people to "come to Texas and see the wares of the State displayed in pictorial and exhibit form, find recreation, amusement and education and steep themselves in the glamour and romance of an empire where the old South, the frontier West and Latin America have met and fused into a great State unique in legend and history."[19]

The Promotion Department's continuing lack of quality photographs hindered Watson's vision. Director of Photography William Langley sent dozens of urgent letters to people and organizations across the state in a bid to increase the department's photography files and illustrate stories coming out of the publicity office.

August 9, 1935

Dear Mr. S —

We are very much interested in obtaining some pictures of longhorns to be used in connection with the Texas Centennial publicity. Please let me know if it is possible for you to have some of these pictures made with two or three pretty girls standing close to the head of the animal.

August 13, 1935

We are most anxious to receive photographs of historical interest or of scenic beauty from your city and surrounding country. *(Sent to chambers of commerce across Texas)*

September 24, 1935

We are endeavoring to build up our photographic files with good scenic views of city and countryside. Will you be so good as to send us any photographs you may have that would be suitable for reproduction. *(Sent to bus lines, airlines, and railways)*

While chambers of commerce and transportation companies sent the requested photos, Langley also dealt with unsolicited photos that poured into the office.

August 22, 1935

Dear Mrs. C —

We appreciate your sending us the photographs of your daughter, and I am sure at some time we will find a place for her in our photographic publicity work. Of course, you understand the models are not paid for their services.

CENTENNIAL PHOTOGRAPHER LANGLEY

William Langley

From the collections of the Texas/Dallas
History and Archives Division,
Dallas Public Library

William Langley had lived a "crowded life"[20] before the Exposition hired him. He was born in Irvington-on-the-Hudson, New York, on June 25, 1898. As a young man, Langley studied at Pratt Institute and worked as a seaman for the American Hawaiian Co.[21] During World War I, he served as a Secret Service agent for the Army. Langley was captured in uniform behind enemy lines and sentenced to execution, but British aviators helped him escape through a garbage dump.[22]

After the war he worked for the *New York Times* and United Press before moving to Dallas in 1924 and working for the *Times Herald*. Langley didn't stay at the *Times Herald* long; instead, he became a secret investigator for the Texas Rangers. His cover was that of photographer. "But then," Langley recalled, "I started making a hell of a lot more money as a photographer than my $240 a month salary as a captain of the Texas Rangers. So I figured 'to hell with it' and quit. That became the beginning of serious photography."[23]

Langley had two particular photographic specialties: dreaming up "gag" shots and finding beautiful women to photograph. Langley listed some of his early Centennial gag shots in a report to Frank Purcell, director of publicity for the Exposition.

Airplane Gag – Took pictures at Love Field of four girls dressed as Pioneer women and one old man dressed as Pioneer man. Stood by Bowen plane which has Texas Centennial sign painted on it.

Roller Coaster Gag – Took pictures of children watching "Lightning" being torn down. Sad expressions, etc.

Dallas Cops at School – Took pictures of pretty girl teaching Dallas cops Texas history. Taken at Police headquarters.[24]

A Centennial Rangerette

Langley probably came up with the idea of the Texas Centennial Rangerettes, a group of attractive young women dressed in chaps and 10-gallon hats who participated in publicity stunts for the Centennial.[25] Their first stunt was to travel to Philadelphia to lay a wreath on the grave of George Mifflin Dallas, the former U.S. Vice President and namesake of Dallas County.[26] In the months afterward, they posed with animals, celebrities, or Exposition attractions—anything that Langley felt would promote tourism to Dallas.

The constant use of "leg pictures"[27] earned a caution from James Crane, the Centennial's publicity representative in Washington, D.C.:

> Pictures could stand more variety—there has been too much stuff of a girl and a horse, a girl and a monkey, etc., and most of these have been posed shots with little action or story. Try something with more punch: let a bull or a cow or a steer break loose in the fair grounds and get a shot of carpenters and girls and spectators running away; let Cliff (the rider and roper) arrive in the nick of time to rope the animal and save Durham, or something. Of course, this kind of stuff is purely stunt stuff, but it does give action and picture editors will print action shots.[28]

Clearly, the situation was getting desperate. What the Promotion Department needed was straight photos of Texas. Watson wrote, "There is a dearth of available photographs suitable for illustrating magazine articles. . . . This could be handled by special assignments to two or three qualified news photographers in the state."[29] But, instead of two or three news photographers, the Exposition chose to hire one woman: Polly Smith.

USE TEXAS PEOPLE

The unemployment rate across the U.S. was over 20 percent in 1935,[30] so when news spread that Dallas would host a major exposition, applications poured in from all over the country for even the most mundane jobs, like cashier. A large number of applicants lived in Illinois. These were people who had worked at Chicago's Century of Progress Exposition in 1933 and '34 and were willing to move to Texas to work for the Centennial. The applicants generally received a short polite reply that said, "It is the policy of the Exposition to use Texas people wherever possible in the organization."[31] Even if you were Texan, it helped to know people in the right places. Politicians from across the state asked Exposition General Manager William A. Webb to "see what he could do" for their friends and relatives.

William A. Webb, General Manager of the Exposition

In 1935, Polly started making inquiries about selling some of her existing photographs of Texas, taken during breaks in her training, to the Centennial. She was aided in her quest by her acquaintance with one of the most influential men managing the Exposition—William Kittrell. Polly probably met Kittrell through her neighbors, Texas folklorist J. Frank Dobie and his wife, Bertha.

In the early 1930s, Minnie had moved from Rio Grande to a lovely stucco house on Park Place. Her home, with its large flower garden in the back, sat near Waller Creek and across from the Dobies. J. Frank Dobie was the leading Texas writer and folklorist from the 1920s to the 1950s. He was born on a ranch in South Texas on

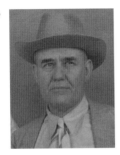

J. Frank Dobie

September 26, 1888, and grew up with a love of reading and literature. In 1921, Dobie joined the Texas Folk-Lore Society and began to run his uncle's ranch in South Texas. Here, he heard the Mexican vaqueros tell what Dobie considered the "true" tales of Texas, rather than the exaggerated stories of current popular fiction by writers like Zane Grey and Louis L'Amour. Dobie, determined to spread the "real" stories of Texas, negotiated a teaching position in the English Department of the University of Texas in 1925. He authored six books during the 1930s, including *Coronado's Children: Tales of Lost Mines and Buried Treasures of the Southwest* (1930), *The Flavor of Texas* (1936), and *Tales of the Mustang* (1936).

Minnie and Bertha Dobie both loved gardening and often sat outside together talking. The Dobies were also longtime friends of the Kittrells. J. Frank Dobie called Kittrell "that prince of storytellers,"[32] and Kittrell considered Dobie one of his "best friends."[33] Kittrell and Polly probably met at one of Dobie's informal gatherings at his Austin home.

Smith home on Park Place Street

Private Collection

At 27, Polly was a trim young woman with thick dark bobbed hair and a spirited and charming personality. Her work uniform was riding pants and a button-down shirt, but she loved tailored suits and coats, exquisitely made by her sister Dorothy and worn with short pearl necklaces. "Polly had great style about her," her sister Gail recalled. "Perfect taste in all she wore—with a special flair—even in the way she arranged furniture in a room or food on a plate. It was her gift of divine inspiration, so vividly revealed in her photographs."[34]

Polly signed a contract with the Exposition as an independent photographer on October 5, 1935. She would "supply the Texas Centennial Central Exposition with photographs, 8x10 glossy, of subjects they select and/or subjects of my own creation."[35]

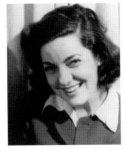

Polly Smith

Private Collection

She retained the rights to her work unless paid $10 for a particular print and negative. Prints only were 50 cents each. The Exposition agreed to buy $500 worth of negatives or prints within 31 days, excluding Sundays. Moreover, they gave her a $100 advance and a $35-per-week travel allowance.[36] After 31 days, the Exposition was free to terminate Polly's contract at will.

Writing to the Exposition's Finance Department, Watson initially thought that Polly's contract would run four to six weeks. In fact, it ran eight months, as Polly provided the Exposition with "the only decent photographs that have ever come out of Texas."[37]

TEXAS TRAILS

Trails that wander and writhe and bend—

Mighty trails. . . . Take them end to end.

— Norman H. Crowell, 1937

For her first major professional assignment, Polly landed in the middle of the biggest promotional effort Texas had ever produced. Only eight months remained until the Exposition opened. The atmosphere in the Promotion Department was intense and excited, as the staff wooed American travelers to Texas.

Polly's inexperience must have shown or perhaps it was the magnitude of the project, for Clyde Vandeburg, chief of the Exposition's Magazine Department, offered her lots of practical tips.

Dear Polly:

Attached you will find a first assignment sheet. Don't let it alarm you. It is long and covers a multitude of subjects and I would like to drop in a word of advice as to the best way in which to secure the material and subjects listed. I realize that many of the topics listed are going to be very difficult to secure, some of them impossible. I listed them because I thought that you might stumble upon something that would fill the requirements, but I do not anticipate or expect you to take long and expensive trips to secure any single picture.

I think it would be best to break down the assignment sheet, grouping as many subjects as possible and on each trip endeavoring to secure as many views as possible on any given

classification. In other words I do not think it would be wise to confine yourself to personality shots on a trip to San Antonio—on the same trip you may be able to pick up a half dozen range scenes, agricultural shots or any one of a half dozen other subjects.

When you find it impossible to secure any one of the views requested, skip it for the moment and go ahead with something else, reporting to me that you were unable to secure a certain shot and unless I can give you the information as to where and how to find it we will cancel it from the list.

From the beginning try to keep me supplied with views of a general nature that can be applied to any one of a half dozen or more magazine stories. Save the specialty stuff or take it as you can, as I have greater need for the general material <u>immediately</u>.

Yours truly,
C.M. Vandeburg[1]

A 27-year-old self-proclaimed country boy from Montrose, Colorado, Clyde Milner Vandeburg was described as "gangling"[2] and having "an everyday face, but with the kind of eyes and mouth that seem to look for something to laugh at."[3] At 22, Vandeburg and his wife, Helen, had moved to California, where Vandeburg planned to write a column for a San Diego newspaper—as soon as one would hire him. He had been a star reporter in Montrose, but the San Diego papers weren't interested. To keep the money coming in, he became a sparring partner for Lee Ramage, a well-regarded heavyweight boxer, best known for fighting against Joe Louis (and losing). Later, he sold brushes door-to-door for two years until, finally, he became the publicity director of the San Diego-California Club.[4]

In 1934, the city of San Diego determined to put on a fair in 1935. Vandeburg took a leave of absence from his job to help promote the California Pacific Exposition with a budget of $100,000. As with the Texas exposition, there was little time left for promotion; however, Vandeburg's efforts were successful, and the Exposition in Dallas immediately hired him to be the chief of the Magazine Department.

The assignment sheet he gave Polly was two pages long and packed with requests ranging from university scenes to "hillbilly shots," and desert scenes to East Texas lumbering. Other items included:

Mohair . . . from goat to garment – from scent to sack cloth – hoof to hide
Textile Shots . . . mills – manufacture – machinery, etc. – housing of employees (if favorable)
Horse Racing . . . few good shots when Arlington Downs opens[5]

DUSTY ROADS AND HEAVY LOADS

Armed with her assignments, a letter of introduction from Frank Watson, and Minnie's fervent prayers for her safety, Polly "started on her long and exciting trip, alone, to photograph all parts of Texas."[6] She had her own car, and she drove out from Austin, staying in hotels along the way.

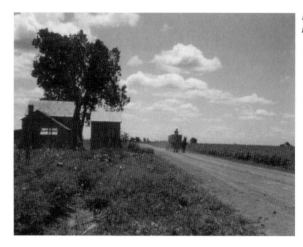

Roads in Texas
by Polly Smith

Driving in Texas was no carefree jaunt. Although Centennial literature advertised "paved highways [that] stretch for miles through Texas,"[7] it didn't mention that those highways were often interrupted by long sections of dirt roads that turned into "impassable muddy ruts"[8] when it rained. In 1930, Texas had 18,728 miles of main highways of which only half were paved. Now, with the Centennial looming and the expectation of "great throngs coming from every state in the Union,"[9] Texas wanted "dustless"[10] highways so that visitors could more easily travel to all the state's scenic delights.

However, the repairs on the main highways probably didn't help Polly as she went to places like San Augustine, New Gulf, and Livingston. To make matters worse, the maximum speed limit anywhere in the state was only 45 mph—a figure considered "antiquated"[11] even then. On many roads, the limit was 20 mph.[12]

Then, too, Polly had to manage the equipment she carried from place to place. When she decided to take up photography as a career, she bought a 5x7 Home Portrait Graflex camera. For much of the twentieth century, photographers prized Graflex cameras for their clear, detailed photos. Manufactured from 1912-1940, the Home Portrait was, as the name suggests, especially suited for portraiture; however, it also worked well for sports and long-range news photography.

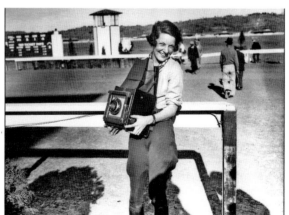

Polly Smth,
Alamo Downs,
San Antonio,
1936

San Antonio Light *Collection, UTSA's Institute of Texan Cultures, No. L-0911-C*

Described as compact, dignified-looking, and rugged, the Home Portrait had a revolving back which allowed the photographer to turn the film itself for horizontal or vertical shots rather than turning the whole camera on its side. It also had a lensboard that could be raised, lowered, or tilted. This feature

allowed Polly to photograph a Dallas skyscraper without tilting the whole camera and risking skewing the lines of a shot. Furthermore, the large-format film combined with the right lenses meant that she could take large, beautifully clear shots of objects from a distance.

Graflex touted the Home Portrait's portability, although, by modern standards, that claim is relative as the camera was slightly larger and heavier than half a cinder block. It was also expensive, probably costing Polly close to $400. For an additional fee, Polly ordered the Special Press Model, which came with a high-speed focal-plane shutter and the ability to fit longer lenses.

The Graflex manual gave careful instructions about holding the camera:

> Rest the camera in both hands, with the fingers under the corresponding front corners of the body. The thumb of the left hand falls naturally on the release lever, while the right thumb and the forefinger are in position to grasp the focusing knob S. To steady the camera, hold it firmly against the chest. To reset the controls after exposure, tilt the camera to the left so it rests on the left hand and forearm.[13]

To take a photo, Polly would first load the 5x7 sheets of film into both sides of a film holder. She would cover each sheet of film with a dark slide to prevent premature exposure to the film, then place the film holder into the back of the camera and rotate it for a horizontal or vertical shot. Next, she'd remove one dark slide.

Polly would look down the focusing hood and make focusing and lens adjustments with the knobs on the corners of the camera. She used her thumb to activate the shutter release. Afterward, she would replace the dark slide and flip the film holder so that she could use the other sheet of film. After she was finished, she would replace the camera lens cap and fold the camera into its case.

Clearly, this was not a process conducive to spontaneity.

SWELL PHOTOS

Polly took her first group of photos in the Austin and East Texas areas. There were many agricultural shots and a few historical in nature. One was a still life of Santa Anna's bridle, pistol, and battle flag, the angle and lighting of which were reminiscent of the class exercises done at the Clarence H. White School. While Vandeburg appreciated her "unusual"[14] shots and thought they were "swell,"[15] he again gave her practical advice. "You want to keep in

mind that the majority of the magazines that we must cover are purely trade publications. . . . I think it would be well to hold the symbolic type of photograph to a minimum. As an example: *Vanity Fair* or *Vogue* would be very likely to accept an angle shot . . . but it would be a total loss with *Cappers Farmer* or the *Angora Goat Raiser.*"[16]

As head of the Magazine Department, Vandeburg was the person most in need of photos to realize the Centennial's goal of attracting new business and development to Texas. To help achieve this goal, he pitched hundreds of stories to the trade magazines. No special interest group was too obscure. Publications that ran articles on the Centennial include:

Peanut Journal & Nut World
Butler County Motorist
Farm Implement News
National Butter & Cheese Journal
American Bicyclist
Florists Exchange & Horticulture World
Texas Food Journal

Centennial publicity materials

The 1930s saw a dramatic rise in the Texas dairy industry, so the magazine division sent Polly's photos of modern milking machines and contented Texas cows to *Holstein-Friesian World* to publicize Texas' growing role in this market.[17] To *Woodworker* magazine they sent Polly's photo of lumbering in the Piney Woods.[18] To the in-house publication of the Illinois Central Railroad, the department sent Polly's photos displaying the scenic beauty of Texas.[19]

In addition to the magazines, the Promotion Department heavily used Polly's photos in Centennial brochures and publications. For example, her photo of the state capitol graced the cover of *Songs Texas Sings*, a songbook distributed to all the schools. Artists would sometimes recreate her photos as drawings and use the illustrations in magazines or promotional material.

In November 1935, Polly took a train from Austin to Harlingen and then rented a car to travel around the Rio Grande Valley.[20] In the 1930s, the Valley had come on strong as a producer of citrus fruits, particularly grapefruit. In just 10 years, Texas had pulled ahead of California as a leading grower of grapefruit and was making gains on Florida.[21] Polly photographed grapefruit trees, grapefruit shipping, orange groves, and citrus processing.

In December, Polly traveled around Houston. She mostly photographed out-of-doors and December 1935 was exceedingly wet. Nearly eight inches of rain fell that month, more than double the average. She described Houston to Minnie as "cold, dark and dreary."[22]

The Houston area included New Gulf and Livingston. In the 1930s, New Gulf was a bustling company town owned by the Texas Gulf Sulphur Company. In 1940, Texas produced 79 percent of all sulfur in the United States[23] and the Promotion Department used Polly's photos to show the rest of the country Texas' importance in this industry.

Josephine "The Weaver" Battise at the Alabama-Coushatta reservation near Livingston

Livingston was close to what was then Texas' only Indian reservation. At the end of Polly's first assignment sheet, Vandeburg had added a postscript: "Doubt if you can get them but if possible get us some live Indians. . . . There is a tribe of Seminoles in Polk County at Livingston."[24] In fact, they were Alabama-Coushatta Indians, not Seminoles. Unfortunately for the romantic visions of Watson and Vandeburg, the tribe had experienced a profound transformation in the past 30 years under the influence of Presbyterian missionaries. Whereas men and women of the tribe had worn buckskin clothes and lived in large log cabins at the start of the twentieth century, by 1932, the Alabama-Coushattas wore Anglo-style clothes and lived in frame houses.[25]

FAMILY HELPS OUT

Minnie frequently acted as Polly's office manager during her travels. The house on Park Place served as a central processing point for photographic requests from the Promotion Department. Minnie would receive the orders and hold them until Polly came back to Austin, or, if she was able, fill them herself and send the requested photos to Dallas.

Polly's brother Bill also helped out. Bill Smith was a student assistant to Eugene Savage from Yale University. Savage had been selected to execute two large murals for the Texas Hall of State—the premier building of the Exposition. Bill acted as courier between Austin and Dallas, delivering photographic orders to the Magazine Department.

TROUBLE IN DALLAS

While Polly was traveling around the state, trouble was brewing back in the Promotion Department. From the start, the organizers knew that expositions like the one they were building seldom returned a profit.[26] The Depression was ongoing, state and federal funds were finite, and, while exhibition space was selling, it remained to be seen if the longed-for crowds would arrive. The Promotion Department felt rumblings of concern as early as October 1935, when Watson was asked if he could make do with a smaller budget. By December, Promotion Department staff felt the pinch.

More trouble followed in January 1936 when hostility erupted in the Photographic Department. On New Year's Day, the department hired John Sirigo to oversee the darkroom. Sirigo had been a photographer at the 1935 San Diego exposition and was a friend of Exposition General Manager William A. Webb. Within six weeks of Sirigo's arrival, William Langley was ready to see him gone. In a letter to Phil Fox, chief of the press section, Langley wrote of the "antagonism" and "dissention" that existed in the darkroom. While *The Dallas Morning News* characterized Sirigo as "restless" and "energetic,"[27] Langley called him "volatile." He cited numerous delays in getting photographs out and "finger marks and scratches" on negatives handled by Sirigo's office. Langley ended by saying that the morale and loyalty of the darkroom staff was "almost completely destroyed."[28]

INTER-OFFICE COMMUNICATION

DATE: December 17th

FROM: THE PUBLICITY STAFF

TO: SANTA CLAUS, MR. WATSON AND MR. WEBB

SUBJECT: CHRISTMAS AND THE SPIRIT OF GIVING

'Tis the week before Christmas
> And all through the staff
Not a penny is stirring,
> Not even a draft.
Our bad checks are pushed
> With pen and a prayer
In hopes that a pay check
> Will make them all square.
With the spirit of giving
> We're highly imbued
But the state of our finance
> Demands fortitude.
Now down in the vault
> There are pieces of eight
To banish the wolf
> And sustain us in state.
We arise then in body
> And loudly implore—
Though we've had some advances
> God grant us some more.

Fox passed Langley's report to Watson with the comment, "I do not see with all other branches of the publicity department running smoothly, why the photographic department should be a constant source of worry and inefficiency."[29]

DISASTER IN THE FIELD

Frank Watson standing far left

In the midst of these staff conflicts, the Photographic and Magazine Departments were escalating efforts to break into class publications like *Vanity Fair*, *Vogue*, and *House Beautiful*. From the beginning, the plan had been to wait until a few months before the Exposition opened to target these publications. Now that time had arrived and Polly's "symbolic" and "unusual" photos would play a starring role. But in San Antonio, disaster struck Polly, and, by extension, the Promotion Department: someone stole Polly's camera and film out of her car.

Few details of the theft remain, but Polly's sister Gail recalled that "[Polly] used to get so excited about what she was doing that she often didn't lock [the car]."[30] Only the lens was insured and the money from that would take three months to arrive. Polly referred to the misfortune as "my great loss"[31] and applied to the Exposition for money owed her to pay for new equipment ordered from New York. She wrote, "To say that I need [the money] would be putting it very lightly."[32]

To make matters worse for her, in the weeks preceding the theft, Polly and the Exposition had renegotiated her contract. Now the Exposition paid her a flat rate of $500 per month, which included her travel allowance. In return, she would provide the Promotion Department with 40 "original Texas subjects"[33] per month. With the loss of her camera, Polly couldn't live up to her end of the contract.

She wrote to Watson in March, "I hope you know how much I appreciate your kindness in sending me the check for $250. I also understand your position in allowing me so many advances without having any return but I sincerely hope that within the next week I shall be up with the books and several ahead."[34] The Promotion Department, while sympathetic, made it clear that "we *do* need your pictures right now."[35] Polly took pains to convey that she would try to make up the loss to the Centennial by shooting "everything that gets in my path when I get the new camera."[36] She would have to travel fast to make up the lost time and wrote, "I work as it is from sun up to sun down and far into the nite (*sic*) developing."[37]

While waiting for her new camera, Polly put the finishing touches on a new tool to aid her work: a Ford truck on back of which a cabinetmaker had built a fully equipped air-conditioned darkroom.[38] Mobile darkrooms were not unheard-of. During the Civil War, photographers in the field used a portable darkroom tent. In the 1930s and '40s, New York photographer Weegee (Arthur Fellig) famously developed news photos from the trunk of his car at the scene of the event. In 1939, *U.S. Camera Magazine* published an article on a trailer darkroom that sported two sinks, an enlarger, an oil heater, and a stove.[39]

The air conditioner that Polly had was probably not so much an air cooling device as an air circulation and filtration device. According to William M. Danner in *Photographic Hints and Gadgets*, a suitable air conditioning unit might be a small electric fan mounted outside of the darkroom, blowing air through an opening in the wall that was covered with a wire mesh dust filter. "This unit will not provide movie theatre comfort," Danner said. "However, it will effectively ventilate the darkroom with perfectly dust-free air."[40]

The truck helped Polly enormously, as she always developed and printed the photographs on location before moving on.[41] She wrote, "Since acquiring my fine truck, I have forsaken the hotels and may start developing under the first shady tree along the road."[42]

More than two weeks after the theft, Polly returned to San Antonio with new equipment and the new truck to photograph missions and scenes of local color. Although not as calamitous as her previous trip, it was still stressful, with Polly noting, "I really have lost what sense I did have."[43]

THE FINAL PUSH

Watson deemed national exposure crucial to the Exposition. "If we are to avoid [the] possibility of a glorified state or regional fair, the exploitation must be national in scope and coverage. National exploitation of the Exposition means national exploitation and economic benefit to Dallas—for 1936 and for all time to come."[44] To help garner national exposure, the Exposition sought out public relations firms on the East Coast.

New York was home to all major magazines and radio stations, and the Exposition hired H.A. Bruno and Associates to contact these outlets and generate support and publicity for the Centennial. Bruno's representative for the job, Russ Gudgeon, was unstinting in his praise of Polly's photos.

February 14th 1936

Dear Mr. Vandeburg:

I regret that you were forced to leave before we could give you a report on the reaction to the Polly Smith photographs. They, without question, are the best material we have had to date on either Texas or the Exposition and already have provided means of entry into the offices of class magazines which heretofore have remained aloof from our overtures.

For instance, Harry Bull, editor of TOWN AND COUNTRY told our Mr. Bint that the Smith photos compared equally with any taken by his special assignment cameramen-artists ($100-$200 per day). Having shown no interest in the Centennial or the Exposition heretofore, Bull now is willing to talk about a story and tentatively selected twenty of the Smith pictures.
. . .
We could dispose of 1,000 of these photos to class publications alone without considering the syndicates, rotos and travel pages. And we must have art for these mediums beginning not later than March 1.[45]

The next day, Gudgeon followed up his letter by saying that the editor of Texaco's publications had, after canvassing every commercial photographer in Texas, only turned up a few photos of the state, and those were "just fair."[46] Gudgeon came to the same conclusion that the Centennial Promotion Department had reached months before: that no one had ever photographed the state of Texas adequately. Gudgeon told Vandeburg, "You have a gold mine, from a publicity standpoint, in the Polly Smith collection."[47]

Bruno and Associates' contract with the Exposition would prove to be short-lived, but the enthusiasm for Polly's work would not be. Public relations men Douglas Silver in New York and James Crane in Washington, D.C., were equally admiring.

Silver took over Bruno's work and immediately began shopping Polly's photos to *Vogue*, *Travel Magazine*, *Town & Country*, *House Beautiful,* and others. When Vandeburg visited Silver in New York, he telegrammed to Watson, "Smith pictures clicking with class magazines. Be sure and keep her under contract."[48]

Despite the universal acclaim for Polly's photos, getting them in the magazines was proving difficult. One problem was that many of Polly's best photos had already been used in Centennial publicity and distributed all over the country. This killed the exclusivity that the competitive class magazines demanded. Another problem

was timing. Already, the situation was difficult because of the theft of Polly's camera. Now, the magazines were facing short deadlines in which to include Centennial publicity. Vandeburg wrote to Silver:

> It is imperative that we take immediate action on placement of these photographs since all of the magazines mentioned are facing a deadline, and unless we get in promptly, we're not going to get our break.[49]

Although the class magazines were important to national exposure, the Promotion Department was not sitting still waiting on decisions from New York. The department continued its efforts with the trade publications and found new ways to promote the Centennial through Polly's photographs.

In March 1936, Stanley Marcus of Neiman Marcus hosted a Centennial-themed party in the penthouse of the luxurious St. Regis Hotel on New York's Fifth Avenue. As Irvin Taubkin of the *New York Times* put it, "It was a Texas party from the word 'go.'"[50] He reported that partygoers "heard 'The Eyes of Texas' played by a band of strolling wise-cracking cowboys, and joined in, with a loud and ringing Yip-ee-eye-eye."[51] Polly gladly gave Marcus a set of her photos showing the construction of the Exposition buildings at Fair Park. Marcus had the photos enlarged and mounted, then displayed them to guests like Carmel Snow, editor of *Harpers' Bazaar*, Edna Woolman Chase, editor of *Vogue*, and many others.

Stanley Marcus seated on right, 1941

From the collections of the Texas/Dallas History and Archives Division, Dallas Public Library

In downtown Dallas, two of the city's most revered institutions displayed her work. Neiman Marcus' flagship store bought nine of her prints,[52] and the elegant Adolphus Hotel created a photo mural for its bar from 18 of the prints.[53] Polly was not paid extra for these uses, nor did she even know about them until after the images were shown. Nevertheless, she was delighted with the result.

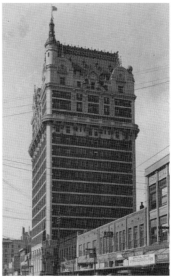

Adolphus Hotel, Dallas, Texas

Polly continued to travel the state. After leaving San Antonio, she returned to Houston before proceeding to Monterrey, Mexico, where she photographed bull fights, donkeys, and local people.[54] She journeyed back to Dallas to photograph the horse races at Arlington Downs and the boaters at White Rock Lake, then headed to West Texas to shoot brandings, roundups, and cactus. Sadly for history, the moment the Promotion Department received the photos from West Texas, they forwarded them to New York for possible inclusion in the class magazines and did not retain copies. None of her photos taken in West Texas are known to exist.

TO MY HUSBAND—DECEMBER 1844

Thy task is done. The holy shade

Of calm retirement waits thee now;

The lamp of hope relit hath shed

Its sweet refulgence o'er thy brow.

— *Margaret Lea Houston, 1844*

Opening day, June 6, 1936

Gail Muskavitch, center, standing in American Airlines plane for the opening parade

At long last, the Centennial Exposition opened on June 6, 1936. For months interest in the Centennial and Exposition had been building. In February, the Centennial information office in Austin received 15,000 requests for literature within a two-week period.[1] In May, *The Dallas Morning News* said that excitement for the Centennial was at a "fever pitch."[2] When the ribbon to the entrance of Fair Park was finally cut, nearly 118,000 people filled the park.

Polly's sister Gail attended the opening day festivities in grand style. As part of the ceremonies, Gail, who worked in radio under the name Gail Northe, arranged with her brother C.R. (then president of American Airlines) to use an American Airlines DC3 to fly over the opening parade and broadcast the event from the air for WFAA Radio.[3] In the plane with her were Governor Allred, R.L. Thornton, Dallas Mayor George Sergeant, Clyde Vandeburg, and others. Flying about 500 feet over the parade, the plane's occupants dropped fresh gardenias into the crowd as a "floral gift offering."[4]

With the Exposition open, the Promotion Department turned its efforts to the

ongoing events and allowed Polly's contract to run out. She had traveled 3,600 miles in eight months—the equivalent distance of Tallahassee, Florida, to Fairbanks, Alaska.

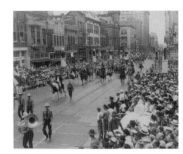

Centennial Exposition opening day parade in Dallas, Texas

For a while, she freelanced for Chrysler, an exhibitor at the Centennial, before moving on to other projects.[5] But the Centennial accorded her a final accolade when the Texas Hall of State belatedly opened to the public on September 4, 1936.

THE TEXAS HALL OF STATE

The Hall of State was the focal point of the Fair Park Esplanade. Workers on 24-hour shifts[6] had finished the exterior in time for the Exposition's opening, but the interior took longer. The building had been conceived and executed as a shrine to Texas and a memorial to the Centennial, and, as such, its opening was a major event.

Centennial Exposition esplanade with Hall of State at terminus

The Dallas Morning News sponsored a contest among its reporters to see who could write the best story about the Hall of State and the reporters responded by piling on the superlatives.

> The dignity of the structure is inescapable and so overpowering that men walking through its portals, standing face to face with the heroes of the past, instinctively remove their hats. Visitors lower their voices as if they were within the walls of some great cathedral. Even children cease their scampering and walk quietly from display to display. — Eugene C. Wallis, September 20, 1936

> Breath-taking in its brilliance and sheer beauty, the glistening exterior of the Texas Valhalla is only a fitting preface to the awesome interior of the building, where no citizen of any state or land can enter without coming out better for the experience and with profound appreciation for founders of the Lone Star State. — Barry Bishop, September 23, 1936

> Impressive in its stateliness, chaste lines and immensity when viewed from the opposite end of the Esplanade of State, which it dominates, the structure is even more enchanting inside. Its exhibits realistically unfold the romantic story of the Cavalcade of Texas to visitors from other states and make tears of pride well into the eyes of native sons, largely because of the startling effectiveness of the architectural treatment, furnishings and decorations. — John Terry Hooks, September 24, 1936

Polly Smith's images in the Texas Hall of State

Dallas Historical Society, Harrison Evans

To be fair, the Hall of State deserved the praise; the building was and remains a triumph of Texas patriotism and craftsmanship. Approaching the grand entrance to the Texas limestone building, the graceful and powerful gold-leafed statue of the Tejas Warrior by Allie Victoria Tennant greeted Centennial visitors. Huge bronze doors decorated with Texas motifs like cotton and lariats opened into the semicircular Hall of Heroes, where people saw the great men who helped form the Republic of Texas cast as six large bronze statues by Pompeo Coppini. To the left, two regional rooms held historical exhibits from European colonization to 1836. The West Texas room evoked the desert-like cowboy image of the state and featured two large murals by Tom Lea, while the East Texas room reflected the forests of Texas and displayed two large murals by Olin Travis.

Centennial artists from left to right: Eugene Savage, Bill Smith, George Davidson, and Reveau Bassett

To the right, two more regional rooms held historical exhibits showing the state from 1836 to 1900. The North Texas room suggested the open prairies of the region and offered the building's only fresco, one done by Arthur Starr Niendorff. The connecting South Texas room had walls burnished with aluminum leaf and a lush mural done by James Owen Mahoney, Jr.

The Great Hall stood straight ahead from the building's entrance and could fairly be compared to a cathedral. A *Dallas Morning News* reporter said of it, "Sixty feet wide, ninety feet long, and with a forty-five foot ceiling, the room gives one the feeling that at last he can be within four walls, take a deep breath and stretch luxuriously without upsetting anything."[7] The Hall had a 12-foot medallion at the end, leafed with six different types of gold. On the walls, two-story murals showed Texas history from the 1500s to 1936.

Close-up work done by Bill Smith for Hall of State murals. The airplane is a tribute to his brother, C.R. Smith, and he painted himself as the artist.

Polly's brother Bill had assisted Eugene Savage with the Great Hall's murals and took the opportunity to paint in something personally meaningful. On the right-side mural, which showed modern Texas, Bill painted an American Airlines airplane near the top—a tribute to his brother C.R. He also painted himself as the artist in the mural, gazing toward the plane.[8]

The Hall of State planners meant for the building to awe visitors, and it did. It presented the larger-than-life story of Texas with soaring spaces and monumental artwork, thereby epitomizing the word "Texanic." However, within this colossal shrine made of limestone, granite, and marble were a few grace notes of reality. Again unbeknownst to Polly, the Hall

of State interior designers enlarged some of her photos and permanently mounted them on the walls of the North and East Texas rooms.

Amidst the Hall's romantic and stirring imagery were Polly's peaceful black-and-white photos of children on a wagon, a farmer in the field, and even Polly herself walking through the pines. With all the celebration of the past in the Hall of State, Polly's photos made a connection to the present.

Oddly, writers tended to overlook Polly's photos when they described the artwork in the Hall of State. Even the grandiloquent prose of the newspaper accounts failed to mention her photos. If a book or article did recognize them, it was only a sentence here or there. This exclusion may have had its roots in the debate over whether or not photography was really art, but, whatever the reason, the omission persisted through the decades.

POLLY'S REPUTATION GROWS

After the Centennial, shots Polly had taken on her travels continued to appear. In 1939, *The Dallas Morning News* noted that she had recently sold the 1000th print[9] of a photo taken during her Centennial travels: an image of the Kokernot Ranch near Alpine, Texas (image unavailable).

Texas Parade, a monthly magazine endorsed by the Texas Highway Association, often used her Centennial photos within the magazine and on the cover. In December 1938, they named her one of the "Faces of the Month" and said she was "one of Texas' finest artists with the camera. . . . Miss Smith uses a vivid imagination that gives her photographs a unique distinction in the pictorial arts."[10]

The 1936 book *You and Your Camera* by Eleanor King and Wellmer Pessels briefly discussed Polly herself and her position as a Centennial photographer. Inclusion in this book came about when Russ Gudgeon of H.A. Bruno showed her photos to the staff of *Pictorial Review*, where Pessels worked. Pessels saw the photos and immediately wanted to include them in a book she was writing with the working title *Camera Why's*. This caused a misunderstanding that lasted for months, as Gudgeon, and subsequently Silver and Vandeburg, thought the book was a publication of *Pictorial Review*, and thus *Pictorial Review*—with its 2 million readers[11]—would be promoting the Centennial. Silver finally untangled the matter when he spoke to the editor of *Pictorial Review*. Writing to Clyde Vandeburg, Silver said:

> PICTORIAL REVIEW: This publication is not using and had no intention of using a story on the Exposition. Pictures requested were by Miss Pesseles (*sic*) who wants them for a book on amateur photography which she is publishing this fall—pictures were not for magazine, with which she happens to be connected. However, I spoke to Mr. Mayes on the editorial staff and he says he will give us an editorial in May or June issue.[12]

WEAF Tower by Margaret Bourke-White

WEAF Tower/Margaret Bourke-White Papers, Special Collections Research Center, Syracuse University Library

You and Your Camera also furthered a piece of misinformation regarding Polly's training: it said that Polly had studied for two years under Margaret Bourke-White. This misconception was fairly common. *The Dallas Morning News* reported it in 1936,[13] and James Crane of the Washington, D.C., publicity office referred to Polly as the "Bourke-White girl."[14] Vandeburg, too, wrote to the editor of *House Beautiful*, saying that Polly had studied for two years under Bourke-White,[15] but there is no evidence that she did so. The closest connection that can be made is that Margaret Bourke-White took a class from Clarence H. White at Columbia University in 1922, and Polly attended the Clarence H. White School of Photography from 1933 to 1935. However, Polly admired Bourke-White's work[16] and took inspiration from Bourke-White's early 1930s photos.

DALLAS AVIATION SCHOOL

In the late 1930s, Polly freelanced for different companies. Regarding a job in the summer of 1938, she wrote, "Houston is a wonderful place for an industrial photographer who is willing to climb on top of cotton compresses with 5 or 6 big lights, cameras and tripod."[17] Her longest job was doing publicity for the Dallas Aviation School from 1939 to 1942.

Polly Smith (right) and Flo Smith (left) at the Dallas Aviation School

Private Collection

Major William F. Long, a World War I Army pilot and internationally rated polo player, founded the Dallas Aviation School in 1926. The school got a boost in 1939 when Long and seven other flying school operators were summoned to Washington, D.C. There, General H.H. Arnold, chief of the Army Air Corps, told them, "I want you to go home, mortgage your houses, sell your wives' furs, borrow all the cash you can lay your hands on, and build the world's best flying schools. . . . At the end of the month, I'm giving you each 100 cadets, . . . and on July 1, I'm giving you all the government planes and training equipment I can find."[18] With that, the school started training American cadets and mechanics for the U.S. Army Air Corps and British cadets for the Royal Air Force. By the end of the war, the school had trained about 25,000 pilots and mechanics.[19]

Polly's sister Flo joined her at the school. Flo had previously been the society editor at the *Dallas Dispatch-Journal* and had a gift for writing. Together, they turned out simple and powerful ads that were far more sophisticated than those for competing schools. One 1940 ad had a large close-up of a sundial and read:

Time Flies Too

Moments have wings. Each tick tock of the clock means a precious moment has flown out of your life forever.

You cannot recapture time but you can build up time by learning to fly. In your log book, minutes become hours. Each hour you fly brings you nearer your goal—an expert pilot capable of holding a job with a major airline.[20]

PEARL HARBOR

When Polly started at the Dallas Aviation School, it was clear that trouble was abroad. A January 1939 *Los Angeles Times* article urged travelers to see America that summer, as "Europe and the Orient are currently psychopathic and give one the jitters."[21] By the time she left the school, war had spilled over into America.

Sunday, December 7, 1941, was a cloudy but warm day in Dallas. Sports-minded Texans were rejoicing over the University of Texas Longhorns' 71-7 annihilation of the University of Oregon's Webfoots the afternoon before in front of a home crowd at Austin's Memorial Stadium.[22]

As news of the attack on Pearl Harbor started coming out, the talk of football and Christmas came to an abrupt halt. People at first didn't believe the news and thought they were hearing something similar to Orson Welles' 1938 *War of the Worlds* broadcast.[23] When they tore themselves away from their radio sets, Dallasites took to the streets to comfort each other. *The Dallas Morning News* reported:

> Through the throng ran a feeling of comradeship Saturday did not know. Strangers conversed and suddenly were friends. Something bigger than individuals or formality united them. Japan had done with a few bombs in an afternoon what threats, cajolery and oratory had failed to accomplish in two years—bound the American people tightly together in a single course of action.[24]

The attack at Pearl Harbor generated a surge of patriotic fervor in Dallas. As a *Dallas Morning News* headline concisely put it, pacifists were scarce.[25] Texans talked of doing to Japan what the Longhorn football team had just done to Oregon's Webfoots.[26]

On Monday, December 8, hundreds of men deluged the recruiting stations and signed up for military service. Women were not allowed to enlist in military service, but men and women, young and old alike, wanted to do something—anything—to help their country. President Roosevelt inspired the nation when he addressed them

on December 9, 1941: "We are now in this war. We are all in it—in it all the way. Every single man, woman and child is a partner in the most tremendous undertaking of our American history."[27]

Before Roosevelt's speech was even over, Polly and her sister Flo had come up with a plan of action—a way to feel like they were doing something to support the state and country that they loved. They and two friends formed the Liberty Belles, a volunteer organization for single working women between the ages of 18 and 30. Exceptions must have been made, though, since Polly herself was 34.[28]

Dressed in plain, neat, blue suits with bell-shaped buttons, the Liberty Belles would sell defense bonds and stamps door-to-door in Dallas. They even talked of working extra jobs and turning the money over to Uncle Sam for the war effort.[29]

GENERAL SMITH

Major General C.R. Smith, 1945

Courtesy Fort Worth Star-Telegram Collection, Special Collection, The University of Texas at Arlington Library, Arlington, Texas

Whether the Liberty Belles ever took off is not known, but the Smith family actively supported the war effort. Polly's brother C.R. had become president of American Airlines in 1934,[30] but temporarily resigned to join the Army Air Force as a colonel and serve as the chief of staff for the Air Transport Command (ATC) under Brigadier General Harold L. George.

The ATC carried cargo and supplies to U.S. troops around the world and was crucial to the war effort. Called "flying boxcars,"[31] the ATC transported diplomats and military personnel, military equipment like ammunition and hospital supplies, mail, and even the fixings for a traditional Christmas dinner to troops in Africa.

ATC planes did not have guns and faced long-range Nazi planes in the North Atlantic and antiaircraft fire from submarines in the South Atlantic. The Japanese threatened both the planes and the bases in the Pacific.[32] Nevertheless, the ATC kept flying and triumphed. It pioneered new air routes and managed an outstanding safety record. C.R. earned a large portion of the credit for this feat, and ended his military service as a major general with the Distinguished Service Medal, a Legion of Merit, and a designation of Commander, Order of the British Empire.[33]

MOTHER TO SOLDIERS

Marion Burck
Smith

Private Collection

Back on the home front, Polly's and C.R.'s mother Minnie was using her legendary energy to good purpose. Besides C.R., her two other sons were in the military. In 1942, Lieutenant Bill Smith was drawing maps for the ATC and Lieutenant Burck Smith was commanding a squadron at a naval air base in California, also a part of the ATC. She felt acutely for the mothers whose sons were serving and for the men far from home, so she took a particular interest in the soldiers at nearby Del Valle Army Air Base, which was soon renamed Bergstrom Army Air Field, in honor of Captain John A.E. Bergstrom, killed December 8, 1941, in the Philippines—the first Austin citizen killed in World War II.[34]

Minnie's first project was one she hoped others would copy around the nation. On Saturday nights, the women of Park Place Street would host a sleepover for about a dozen soldiers. The Austin American Statesman wrote of it, "On Sunday mornings, Mrs. Smith personally serves breakfast to the soldiers. . . . Each woman on Park Place contributes 25¢ a week to help pay expenses of the project."[35]

Soldiers were charged 25 cents for their stay so that they would "feel that they are doing their part."[36] Minnie would ask each soldier for their parents' name and address, then write a letter, mother-to-mother, to tell them that the women of Park Place had entertained her son and that he was well and happy. In return, she almost always received a reply, which she kept.

Toward the end of the war, Minnie retired from her job and spent untold hours of her time volunteering at the Bergstrom Field hospital. She visited wounded soldiers, brought them flowers from her garden, and helped them communicate with their families. For months, she arranged Sunday afternoon entertainments for the soldiers, like old-time fiddle music and dance performances. After visiting her son Burck in California, she came back to Bergstrom loaded with new ideas for occupational therapies,[37] like woodcarving and leatherwork. It's a testament to the esteem in which the hospital administrators held her that they readily adopted her ideas. Newspapers called her a mother to the hundreds of servicemen stationed in Austin and, years later, they still lauded Minnie for her tireless effort on the soldiers' behalf.[38]

A CAREER ENDS

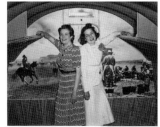

Polly Smith (right) and her work, as displayed in a Braniff airplane

Polly left the Dallas Aviation School early in the war and returned to freelancing, working for Falstaff Brewing, the Matador Ranch, and Delta Airlines. In 1943, she moved to California but couldn't find a job in photography. To make ends meet, she worked as a carpenter's helper for Douglas Aircraft until she took over her sister Flo's vacated publicity job.

Cover photo by Polly Smith, 1945

Private Collection

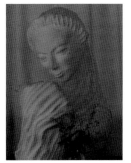

Madonna, by Polly Smith

In the spring of 1945, *The Dallas Morning News* reported that Polly was headed to New York to work as a freelance photographer for *Vogue* magazine, but the assignment, if it ever came through, was apparently short-lived, as *Vogue* has no record of her ever having worked there. Polly stayed in New York and did photography work for American Airlines, including some color covers for their house organ, *Flagship World.*

By 1948 Polly's career as a photographer was ending, but outwardly she remained upbeat, writing to her sister Dorothy, "You know I have never been sold on a career as such." In the spring of 1948, she reenrolled at the University of Texas to study painting and sculpting, which would soon be her all-consuming passions.

Later that year, Polly's mother Minnie became ill, and she and Polly moved to California, where Polly's sister Gail and brother Burck lived.

HAPPY ALL MY LIFE

The 1950s held their share of sorrow for Polly. First, Minnie died in 1950. Then, in 1956, Polly's dear sister Flo Smith Prichard died. After this, Polly lived quietly—reclusively—on her own or with various family members until her death. She took comfort in creative pursuits, continuing to paint and sculpt, but only publicly showing her work once. "Everything Polly did she did for the joy of doing it—never for publicity or competition,"[39] Gail said. Polly also returned to music. As a girl she sang in the school choir; as an adult she played piano on a beautiful mahogany Steinway Grand.[40]

In 1969, Polly moved permanently to Auburn, California, to be with her sister Gail. "She lived up in our guest house," Gail said, "with just apple and orange trees between us. It was simple for us to go back and forth."[41] Although she lived quietly, Polly was not sad, and she enjoyed the company of her siblings and their families.

Polly battled breast cancer in the 1960s, and its recurrence a decade later led to her death. She died in Auburn on June 18, 1980, with no regrets. Gail recalled, "Shortly before [Polly died], she said to me, 'you know I've been happy all my life.'"[42]

Polly loved Texas, calling it the "world's best state!!"[43] Even after she moved to California, she cried when she heard "The Eyes of Texas" played.[44] Polly certainly saw more of Texas than most people. Her years of wandering the state as a child presaged her travels as an adult during the Centennial. In her life she journeyed from Amarillo to McAllen and saw everything between the Piney Woods of East Texas and the mountains of West Texas.

We may never know all we'd like about Polly's work. Her West Texas photos are lost, and her contract work for the airlines and other corporations was frequently published without giving her credit, making it impossible to verify if published photos are hers. Her achievements in later years were modest and marked by a desire for privacy. But Polly's gift to the State of Texas is unassailable: Polly was the first to photograph Texas in all its diversity and beauty. She didn't document Texas—that came later with the Farm Security Administration. Rather, she showed America a vision of Texas beyond the cowboy. She told the story of Texas for the generations to come.

Polly Smith, 1953

Private Collection

IMAGES

Chiseling the finishing touches on a piece of work done at the Texas Quarries. Cedar Park, Texas.

Magnolia Petroleum Building. Dallas, Texas.

Gulf Petroleum Building. Houston, Texas.

Façade of Texas Union, University of Texas. Austin, Texas.

Terrace of the Texas Union, University of Texas. Austin, Texas.

Goddess of Liberty atop the Texas State Capitol. Austin, Texas.

Barton Springs in Zilker Park. Austin, Texas.

Neill-Cochran House. Abner Cook, architect. Austin, Texas.

Plantation home. Houston, Texas.

Ashton Villa. Galveston, Texas.

Crowd scene at Arlington Downs. Arlington, Texas.

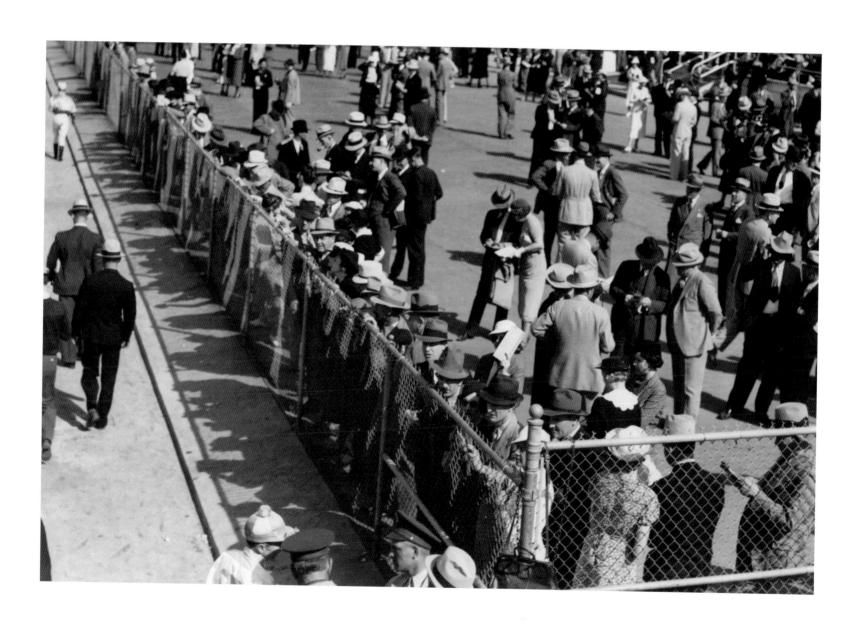

Racing at Arlington Downs. Arlington, Texas.

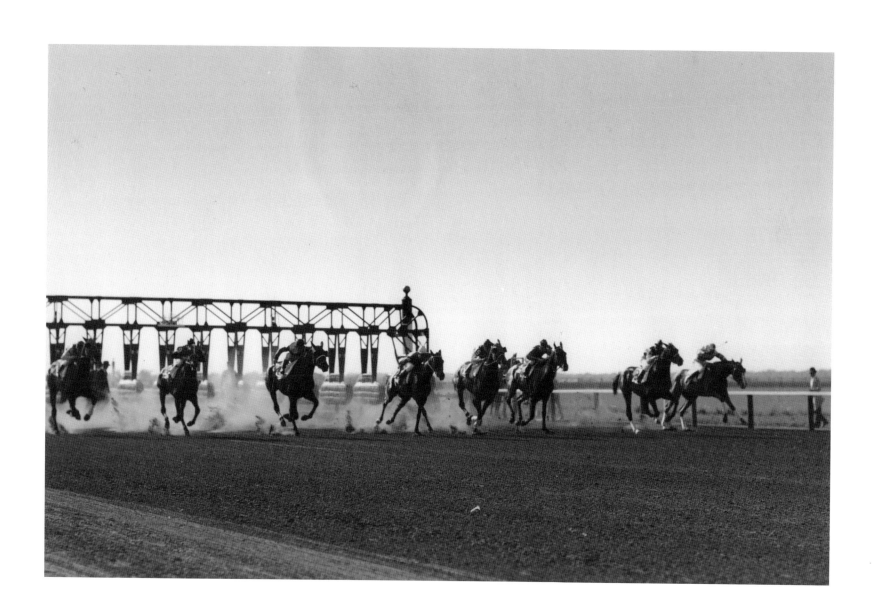

Refueling of a Pan American airplane. Brownsville, Texas.

Pistol Hill. Kilgore, Texas.

Oil drillers. East Texas.

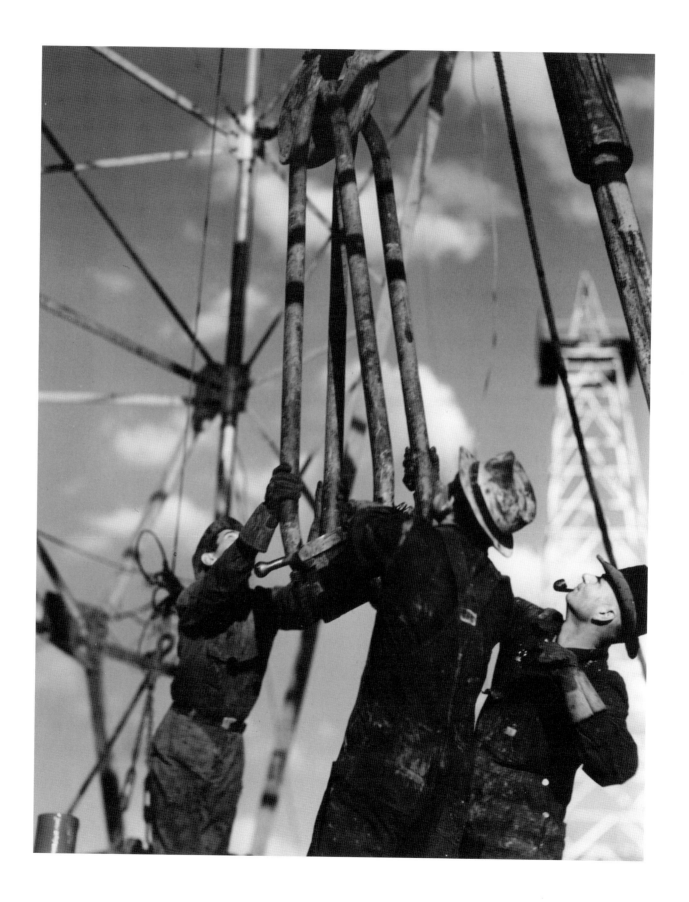

View of derrick looking straight up. East Texas.

Design in an oil derrick. Gladewater, Texas.

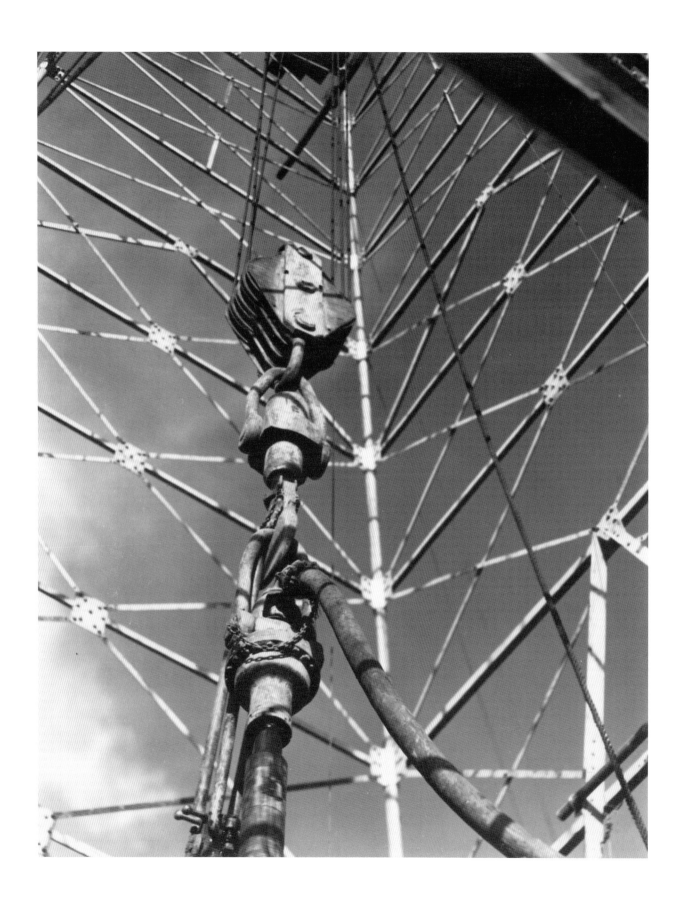

Oil in the casing. East Texas.

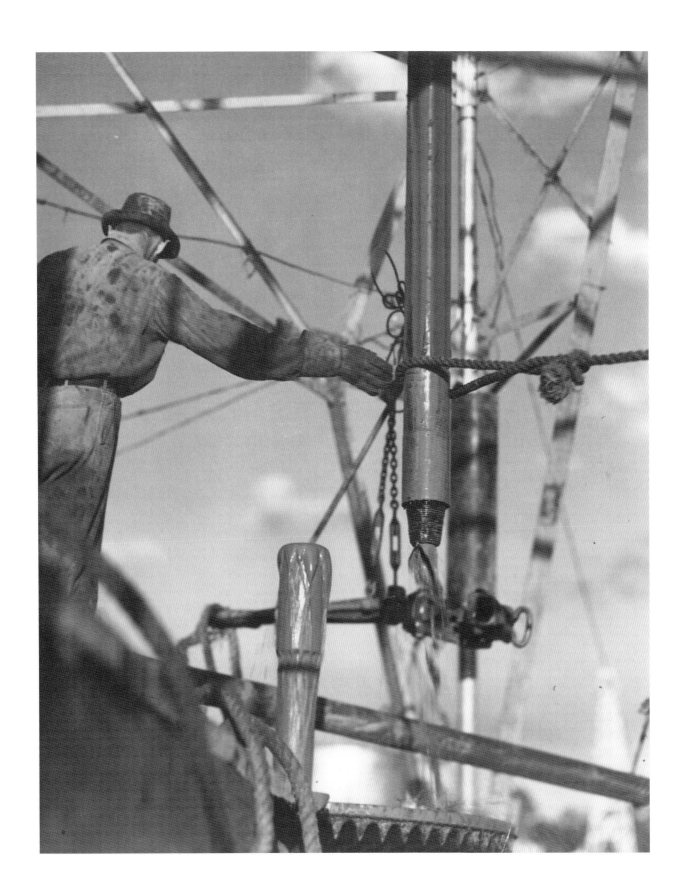

Workmen at an oil derrick. East Texas.

Workmen on oil derrick ladder. East Texas.

Workmen sitting on the struts of an oil derrick. East Texas.

Turning a stone column at Texas Quarries. Cedar Park, Texas.

Grain elevator. Galveston, Texas.

Model dairy farm. Austin, Texas.

Jersey cow at a model dairy farm. Austin, Texas.

Milking machines at a model dairy farm. Austin, Texas.

Milk bottling machinery at a model dairy farm. Austin, Texas

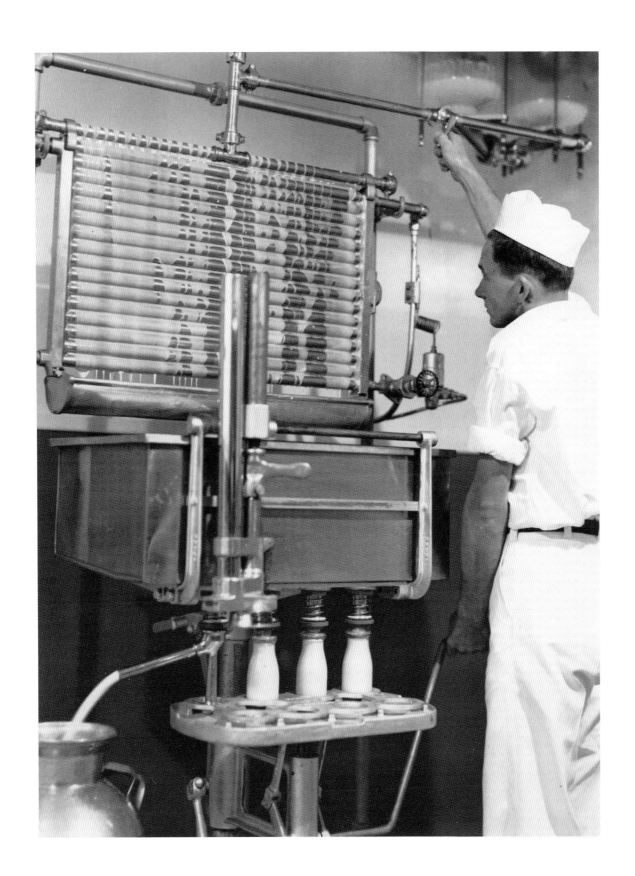

Jersey bull at a model dairy farm. Austin, Texas.

Plow and ox yoke. Location unknown.

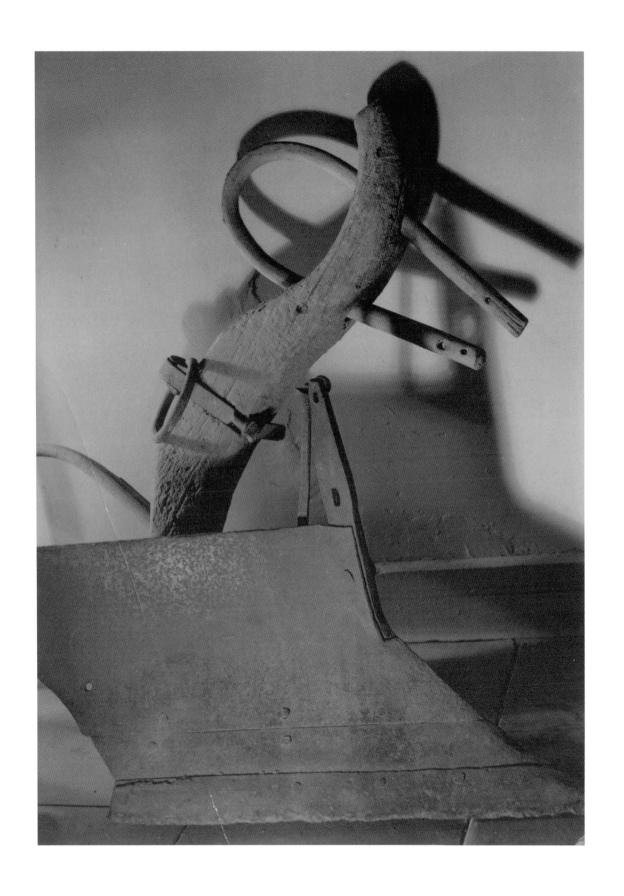

Workers gathering sheaves. Austin, Texas.

Man with hay rake. Austin, Texas.

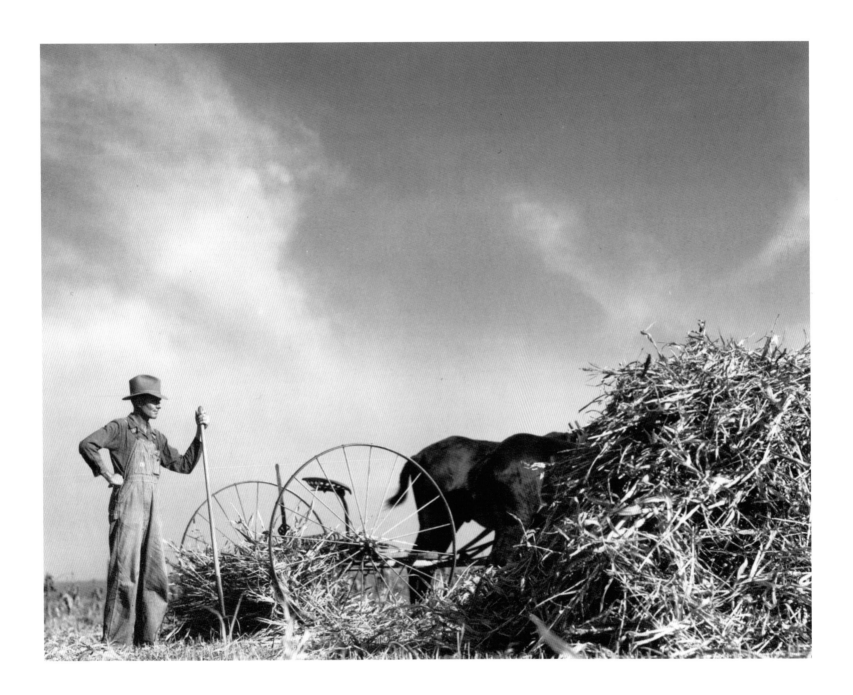

Sorghum. Austin, Texas.

Man on hay rake. Austin, Texas.

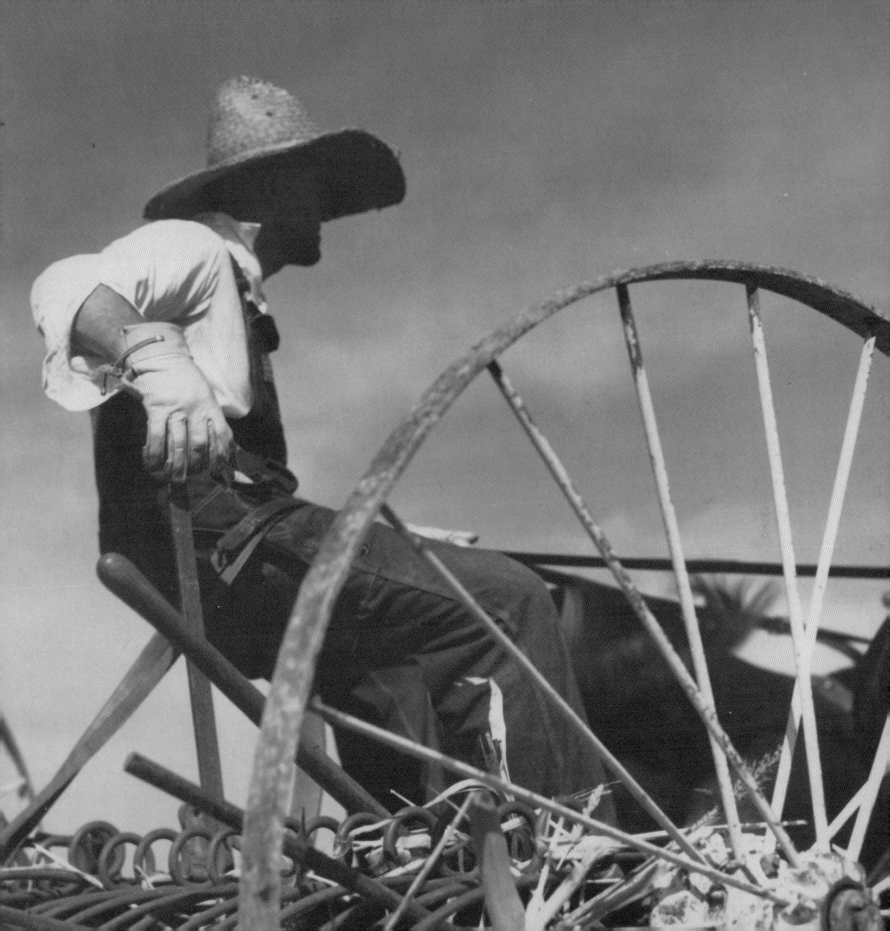

Children in cotton-picking country. Location unknown.

Cotton harvest. Location unknown.

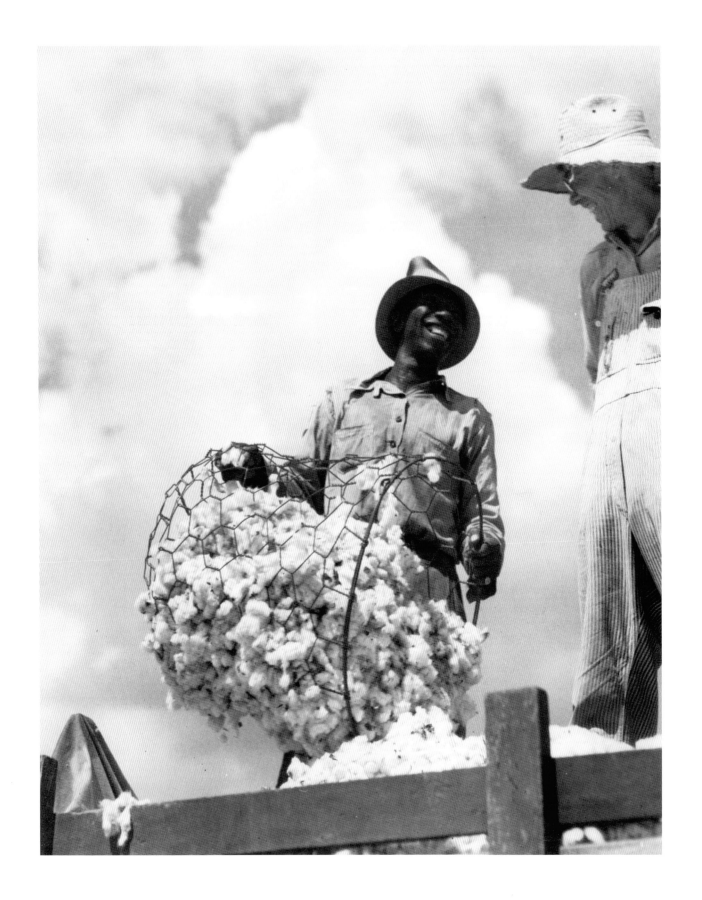

Weighing cotton. Location unknown.

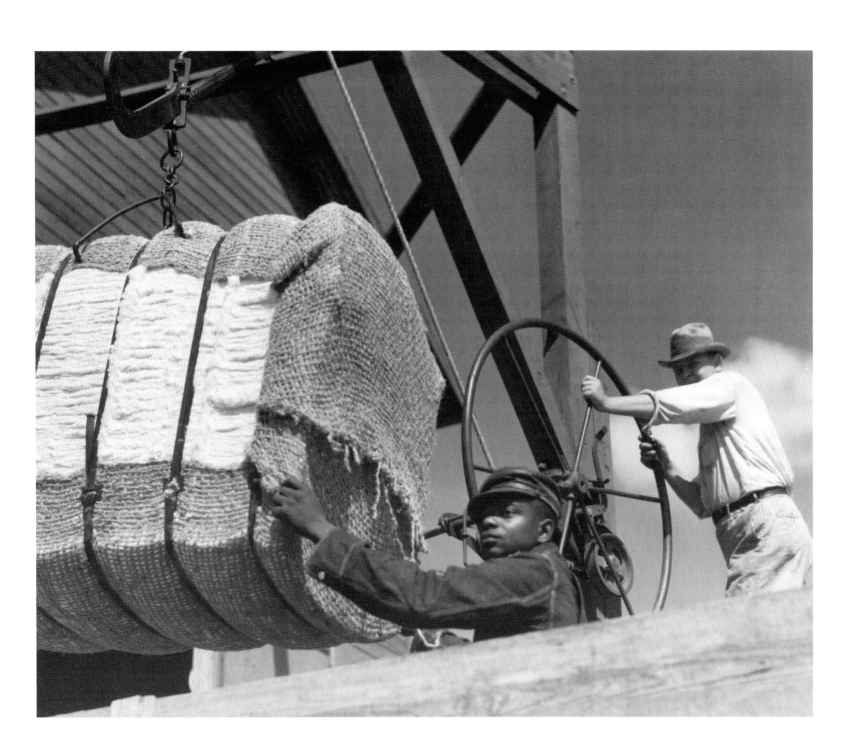

Loading a train with sulfur. Houston, Texas.

Loading a tanker with sulfur. Houston, Texas.

Ferry machinery. Houston, Texas.

Freighter moving through the channel. Houston, Texas.

Fishing boats. Houston, Texas.

White Rock Lake. Dallas, Texas.

Palms on the grounds of the John H. Shary Estate. Sharyland, Texas.

Orange grove. Rio Grande Valley.

Grapefruit cluster. Rio Grande Valley.

Child in front of a maguey or century plant. Rio Grande Valley.

Fruit grading table in a packing house. Rio Grande Valley.

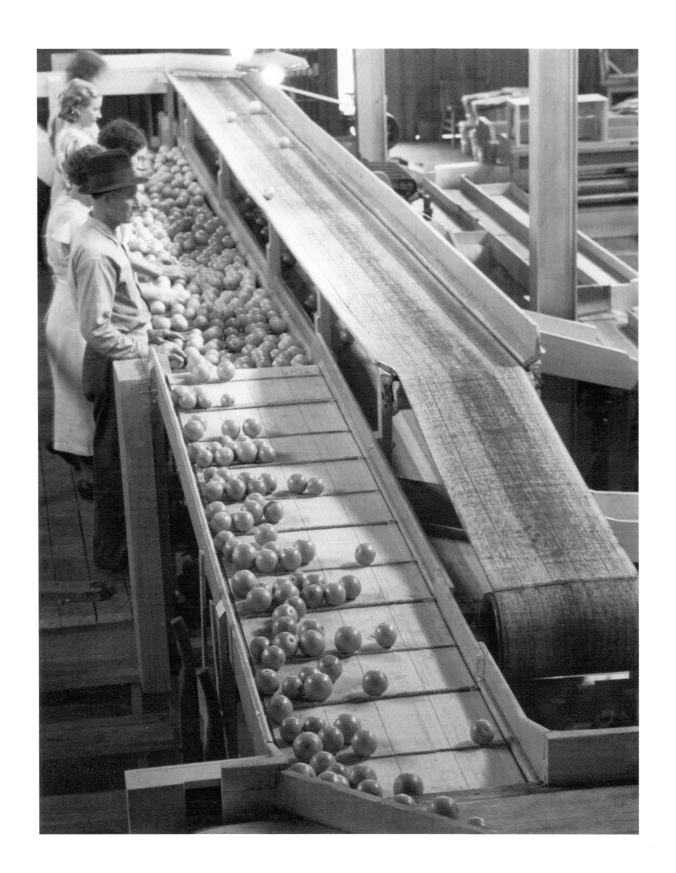

Loading grapefruit. Harlingen, Texas.

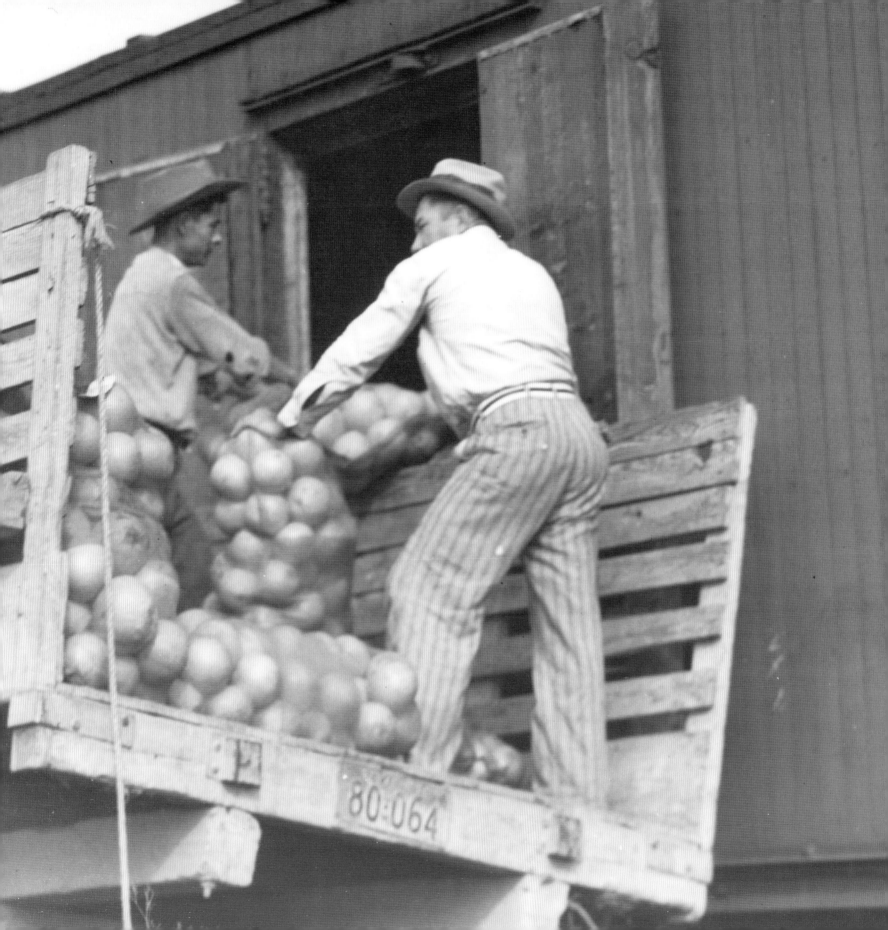

Palm trees. Rio Grande Valley.

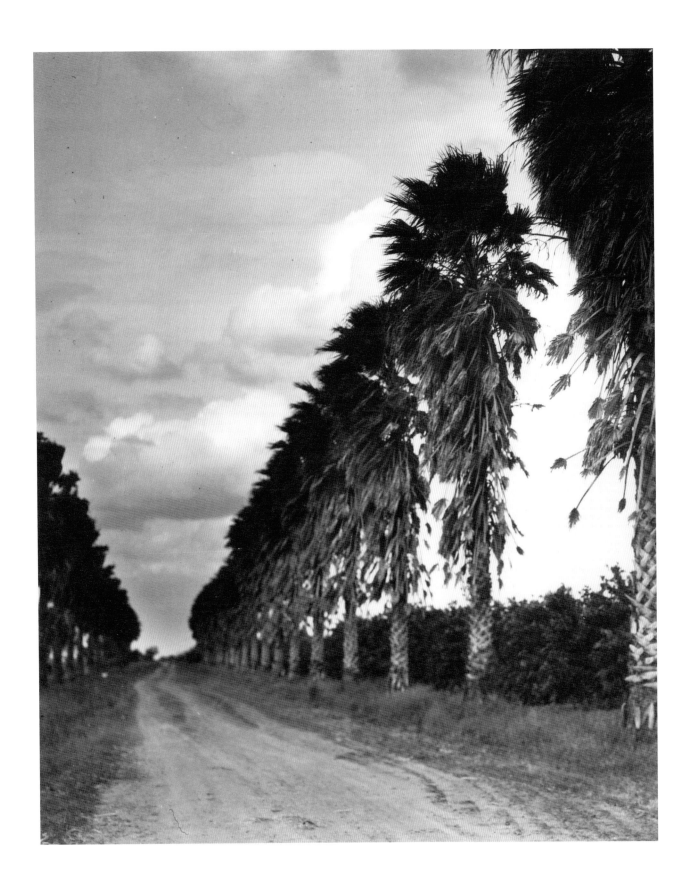

Street Corner. McAllen, Texas.

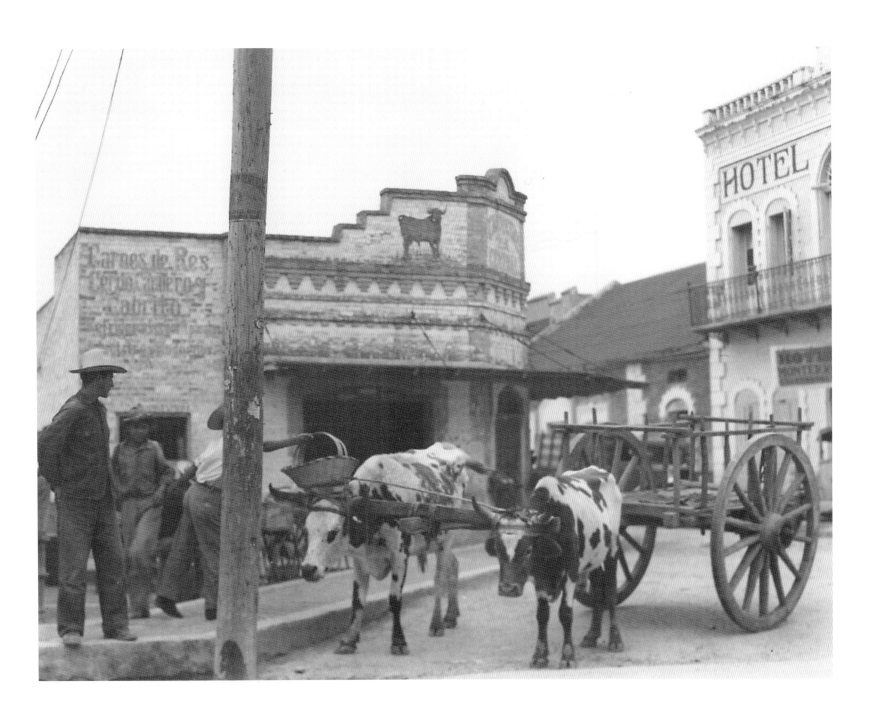

Ysleta Mission. El Paso, Texas.

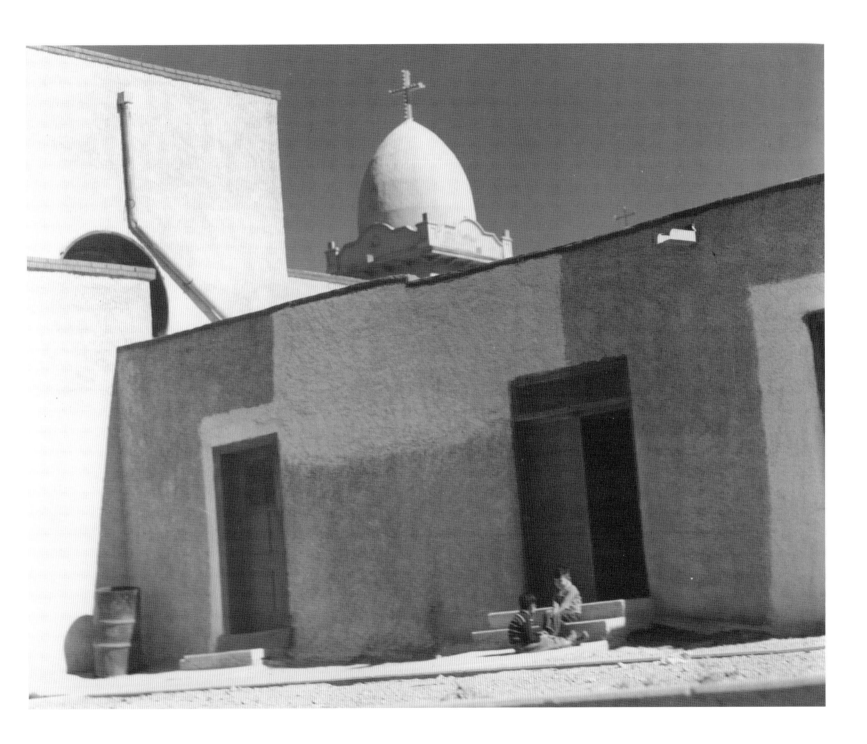

Cara Aspero, Tigua Indian. El Paso, Texas.

Mission Espada. San Antonio, Texas.

Señor with guitar. San Antonio, Texas.

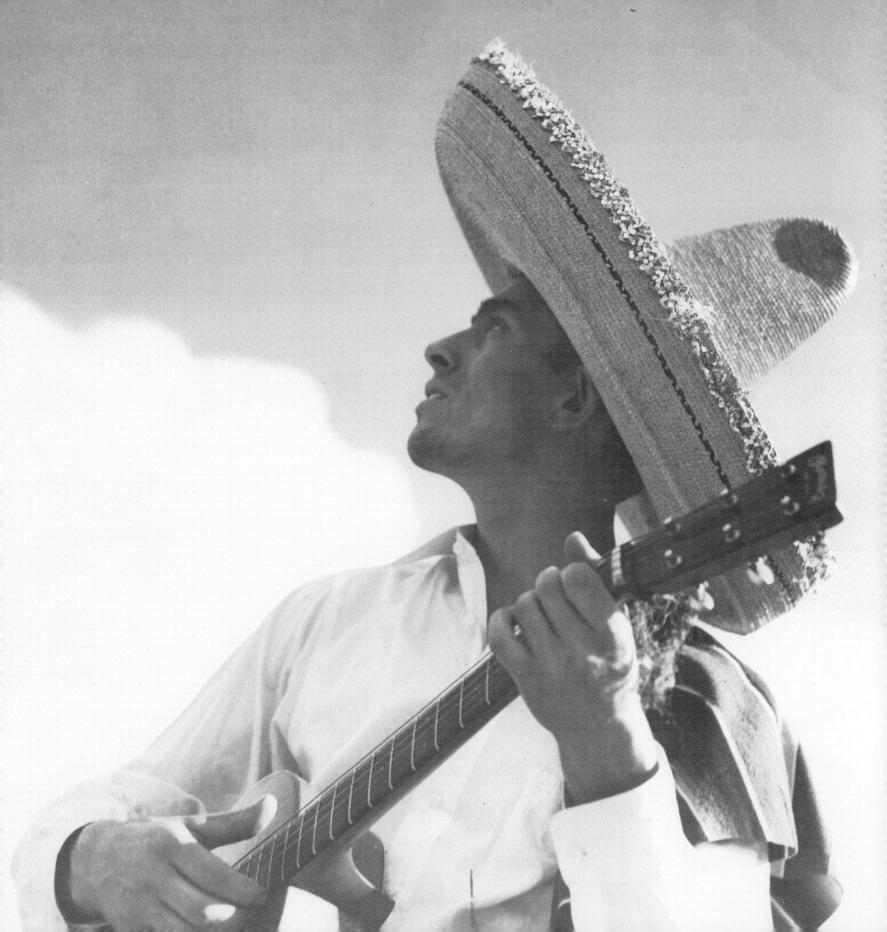

Blind beggar at San Fernando Cathedral. San Antonio, Texas.

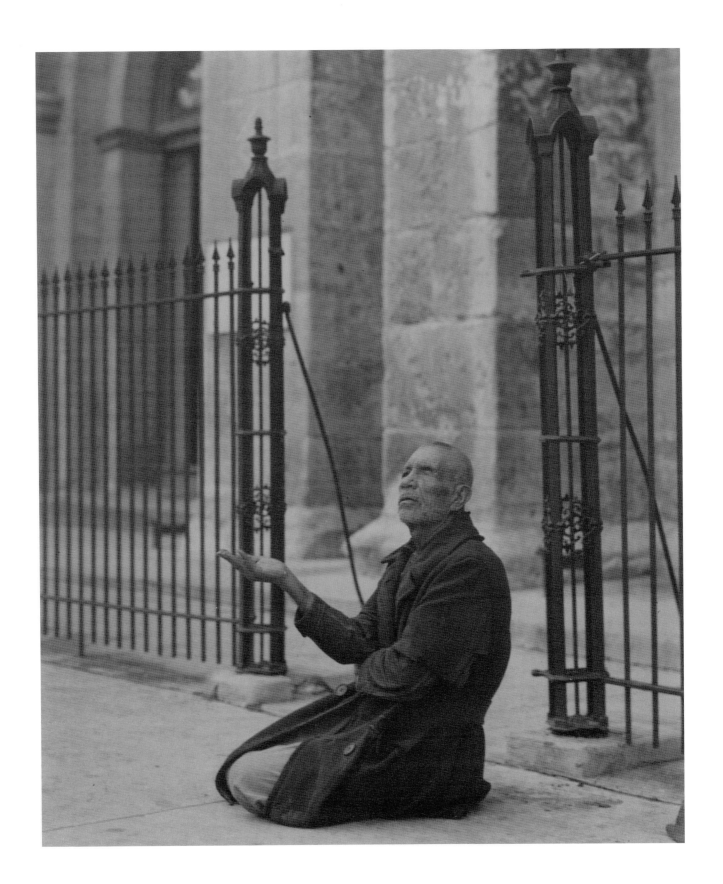

Formosa, the studio of noted sculptress Elisabet Ney. Austin, Texas.

The Rose Window at Mission San José. San Antonio, Texas.

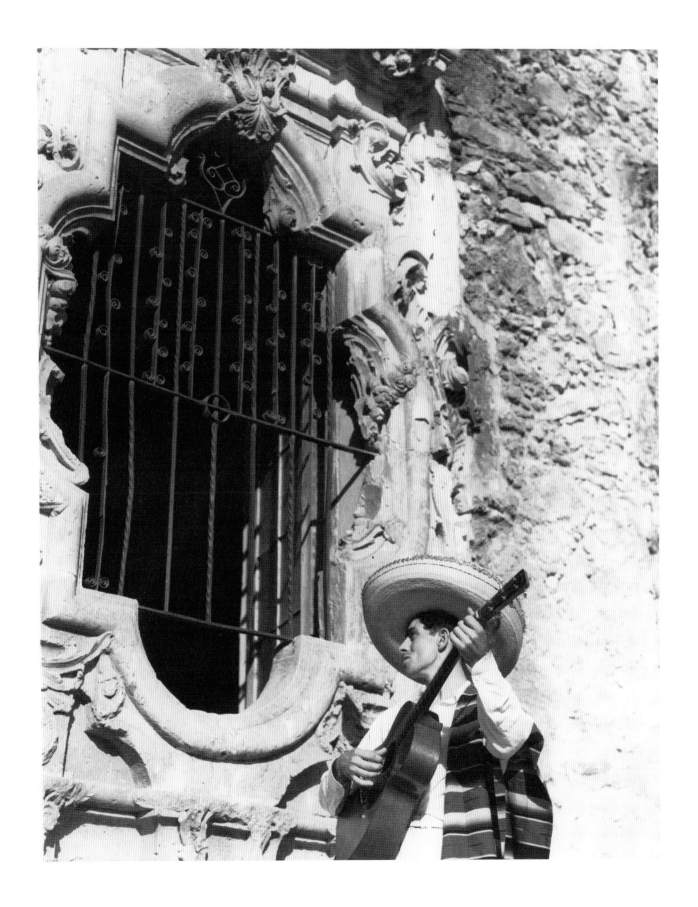

Water lilies. Austin, Texas.

Josephine Battise, basket weaver. Alabama-Coushatta Reservation. Polk County, Texas.

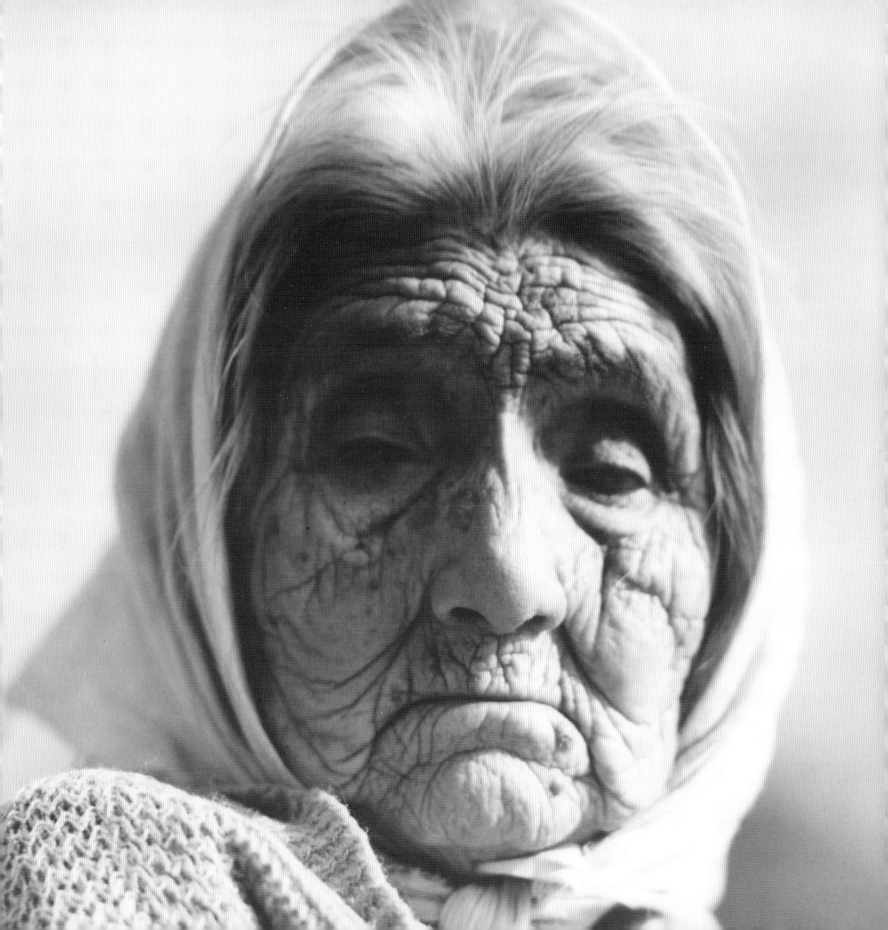

Peppers. East Texas.

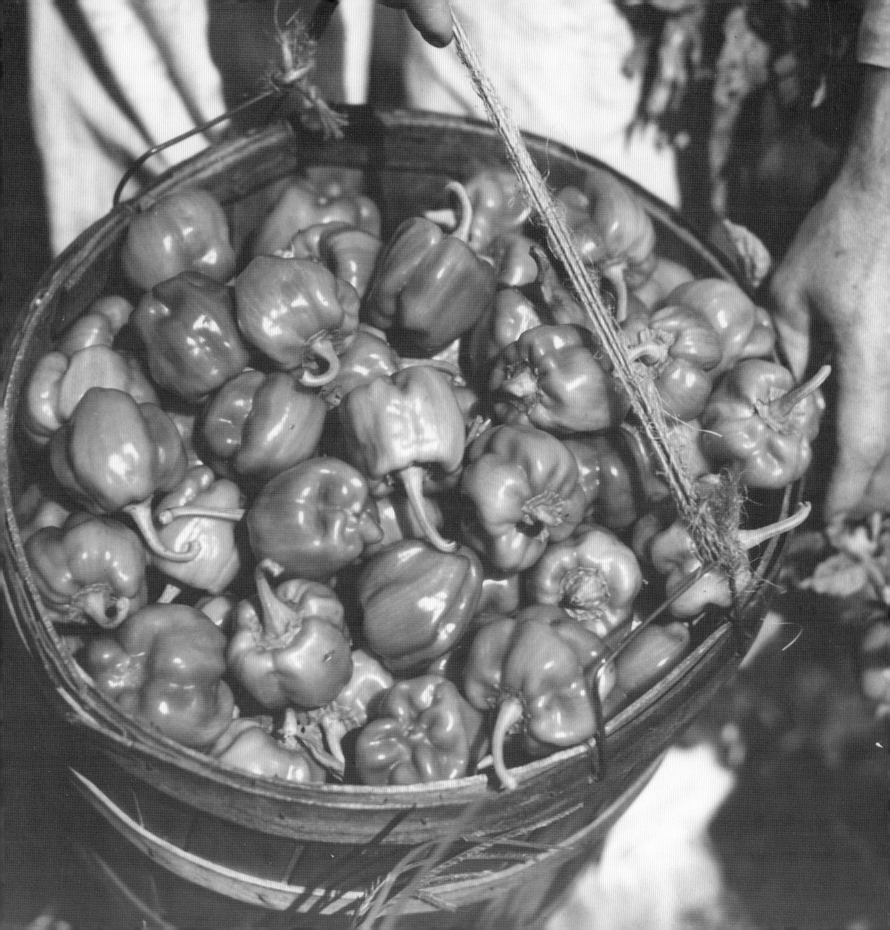

Beulah Henderson and son John Dickson Henderson. Alabama-Coushatta Reservation. Polk County, Texas.

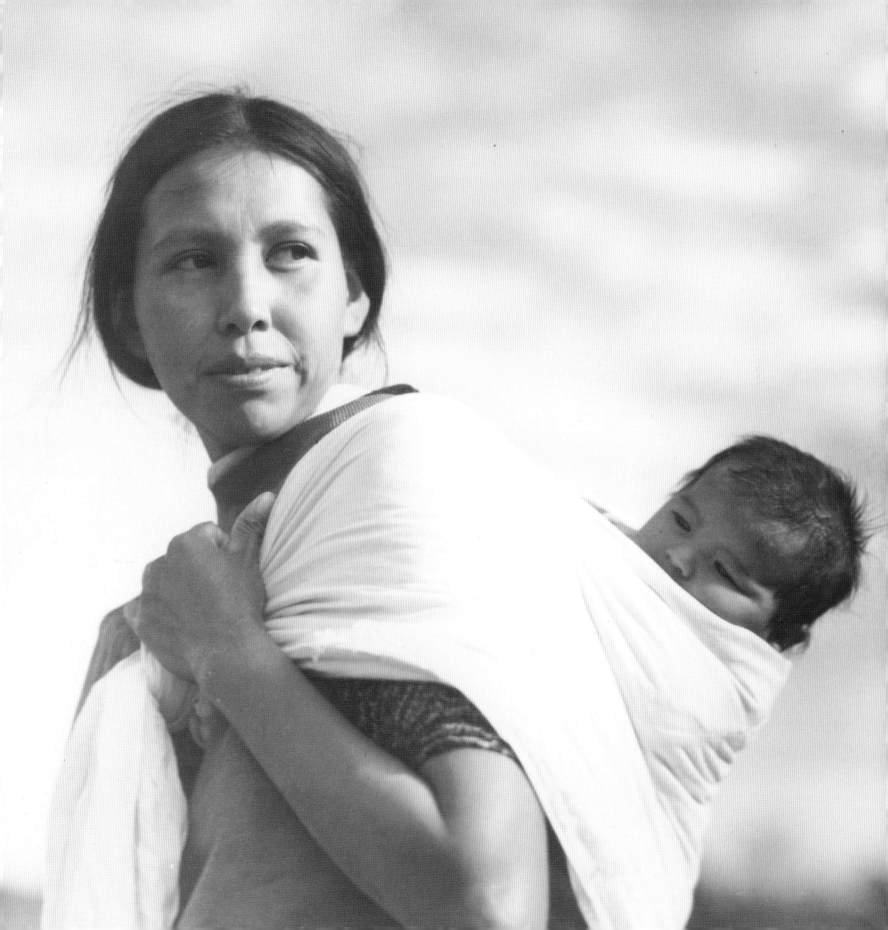

Zilker Park. Austin, Texas.

Polly Smith walking away from camera. Big Thicket area, Texas.

Loading timber. Piney Woods, Texas.

Texas stock saddle and branding irons, including the Turkey Foot brand
of John W. Bunton and the DB brand of Col. Desha Bunton. Location unknown.

Chuck wagon during spring roundup. West Texas.

APPENDIX

Centennial Promotion Organization

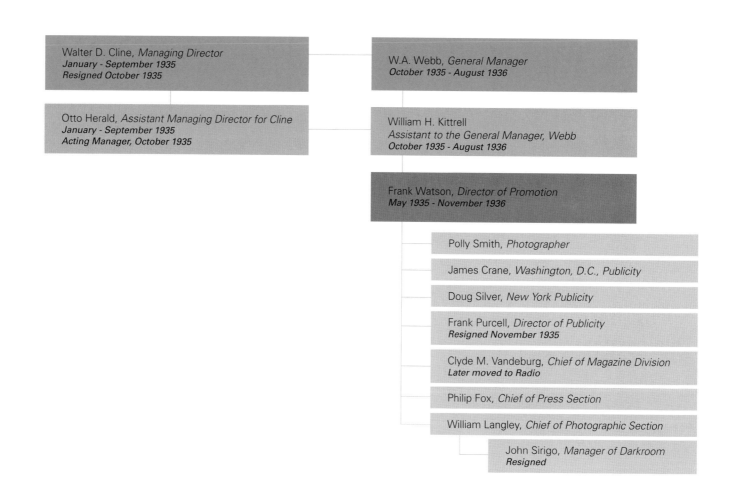

Walter D. Cline, *Managing Director*
January - September 1935
Resigned October 1935

W.A. Webb, *General Manager*
October 1935 - August 1936

Otto Herald, *Assistant Managing Director for Cline*
January - September 1935
Acting Manager, October 1935

William H. Kittrell
Assistant to the General Manager, Webb
October 1935 - August 1936

Frank Watson, *Director of Promotion*
May 1935 - November 1936

Polly Smith, *Photographer*

James Crane, *Washington, D.C., Publicity*

Doug Silver, *New York Publicity*

Frank Purcell, *Director of Publicity*
Resigned November 1935

Clyde M. Vandeburg, *Chief of Magazine Division*
Later moved to Radio

Philip Fox, *Chief of Press Section*

William Langley, *Chief of Photographic Section*

John Sirigo, *Manager of Darkroom*
Resigned

Smith Family Genealogical Record 1846 - Present

Alfred Andrew Burck	1846-1908	
Frances McGowan Burck	1850-1909	

Marion (Minnie) Hudson Burck Smith 1871-1950

Dorothy	1898-1990
Cyrus Rowlett (C.R.)	1899-1990
Mildred (Gail)	1904-
Frances Sutah (Polly)	1907-1980
Carruth (Bill)	1909-1978
Burck Hicks	1911-2001
Floris (Flo)	1913-1956

Cyrus Riley Smith	1837-1916	
Cornelia Orr Smith	1846-1931	

Roy Egerton Smith 1869-1956

Beautiful Texas

Used by Permission
Words and Music by Lee O'Daniel
Copyright © 1933 Shapiro, Bernstein & Co., Inc., New York
Copyright Renewed
International Copyright Secured
All Rights Reserved

All photos are property of the Dallas Historical Society unless otherwise noted.

Agnew, Donald H., and William A. Kinney. "American Wings Soar Around the World." *National Geographic*, July 1943.

Alexander, Jack. "Just Call Me C.R." *The Saturday Evening Post*, 1 February 1941.

Arkadelphia Southern Standard (Ark.), 8 January 1931.

Austin American, 26 February 1936.

Austin American Statesman, 27 November 1942–18 February 1945.

Austin City Directory, 1924–1935.

Austin High School. *The Comet*, 1924–1925.

Austin History Center, University of Texas. "John Matthias Kuehne." Vertical File.

Batte, Lelia M. *History of Milam County, Texas*. San Antonio: Naylor, 1956.

Batte, Mary Belle. "History of Education in Milam County." Master's thesis, Southwestern University, 1 August 1936. http://www.geocities.com/milamco/milam-858g.htm.

Beaumont, Penny, *et al*. "Early Highway Development in Texas." *From Anywhere to Everywhere: The Development of the Interstate Highway System in Texas*. Texas Transportation Institute, Texas A&M University. http://tti.tamu.edu/interstate_anniversary/white_paper/.

Boyer, Doug, and Bruce Carrell. "Information Technology Careers: Past, Present, and Future." Paper submitted in partial completion of the course requirements for MIS 6800: Management Information Systems, University of Missouri – St. Louis, 2004. http://www.umsl.edu/divisions/business/mis/ITCareers.pdf.

Business/Commercial Aviation. "Maj. Bill Long: Aviation's Tall Texan." May 1961.

C.R. Smith Museum. "Cyrus Rowlett Smith Biography."
http://www.crsmithmuseum.org/AAhistory/AA_frameset.htm.

Columbia University. "Early Punch Card Machines." http://www.columbia.edu/acis/history/oldpunch.html.

Dallas, Tex. Dallas Historical Society. Centennial Collection, A38.3.

Dallas Morning News, 22 April 1888–6 December 1997.

Danner, William M. "An Air-Conditioned Darkroom." In *Photographic Hints & Gadgets*. Boston: American Photographic Publishing, 1937.

Dobie, James Frank. *Tales of Old-Time Texas*. Austin: University of Texas, 1984.

Douglas, Jeanne, and Liz Wharton. "Maverick Professor." *Saturday Evening Post*, 11 September 1943.

Ericson, J.E. "Delegates to the Texas Constitutional Convention of 1875: A Reappraisal." *The Southwestern Historical Quarterly* 67, no. 1 (1963): 22-27.

Federal Writers' Project. *New York Learns*. New York: Barrows, 1939.

Flying and Popular Aviation, September 1940.

Fort Worth Democrat-Advance, 1 January 1882.

Fowler, Mike, and Jack Maguire. *The Capitol Story: The Statehouse in Texas*. Austin: Eakin, 1988.

Fulton, Marianne, ed. *Pictorialism Into Modernism: The Clarence H. White School of Photography*. New York: Rizzoli, 1996.

Galveston Daily News, 11 August 1874–26 April 1875.

Galveston Weekly News, 11 March 1875–12 November 1875. http://ftp.rootsweb.com.

Graham, Don. *Cowboys and Cadillacs*. Austin: Texas Monthly Press, 1983.

Hill, Billy Bob, ed. *Texas in Poetry 2*. Fort Worth: TCU, 2002.

History of Texas, Together with a Biographical History of Milam, Williamson, Bastrop, Travis, Lee and Burleson Counties. Chicago: Lewis, 1893.

Hook, Jonathan B. *The Alabama-Coushatta Indians*. College Station, Tex.: Texas A&M, 1997.

Johnston, Frances Benjamin. "What a Woman Can Do with a Camera." *The Ladies' Home Journal*, 14 September 1897.

Leach, Joseph. *The Typical Texan: Biography of an American Myth*. Dallas: Southern Methodist University, 1952.

Magnuson, Diana L. "Selection of Census Supervisors and Enumerators, 1890-1940." NAPP: North Atlantic Population Project. Minnesota Population Center, University of Minnesota. www.nappdata.org.

McElvaine, Robert S., ed. *Encyclopedia of the Great Depression*. New York: MacMillan, 2004. http://continuum.uta.edu.

Milam County Heritage Preservation Society. *Matchless Milam: History of Milam County, Texas*. 1984.

Miller, Sybil. *Itinerant Photographer: Corpus Christi, 1934*. Albuquerque: University of New Mexico, 1987.

Morgan, Willard D., and Henry M. Lester. *Graphic Graflex Photography: The Master Book for the Larger Camera*. New York: Morgan & Lester, 1950.

Morrison & Fourmy's General Directory of the City of Waco, 1898-99.

New York Times, 7 June 1936–24 May 1944.

Palmquist, Peter E., ed. *Camera Fiends & Kodak Girls*. New York: Midmarch, 1989.

Palmquist, Peter E. "Essays." *Women Artists of the American West*. http://www.cla.purdue.edu/WAAW/palmquist/Essays.htm.

Ragsdale, Kenneth B. *The Year America Discovered Texas: Centennial '36*. College Station, Tex.: Texas A&M, 1987.

Research Division, Texas Legislative Council. *The Texas Capitol: A History of the Lone Star Statehouse*. Austin, 1998.

Rice, Bradley R. "The Depression Comes to Taylor." In *Texas Cities and the Great Depression*, by Robert Crawford Cotner. Austin: Texas Memorial Museum, 1973.

Stagg, Mildred. "Woman's Place in Photography." *Popular Photography*, September 1939.

Stephenson, Pat. "Young Man with the Answer." *Los Angeles Times Sunday Magazine*, 8 January 1939.

Taylor Daily Press (Tex.). In Bradley R. Rice, "The Depression Comes to Taylor." *Texas Cities and the Great Depression* (Austin: Texas Memorial Museum, 1973), 30.

Texas Parade. "Faces of the Month." December 1938, 28.

Texas State Historical Association. *Handbook of Texas Online.* http://www.tsha.utexas.edu/handbook/online.

Time. "Ladies' Line-up." 15 February 1937. http://www.time.com/time/magazine/article/0,9171,882704,00.html.

Time. "Letters." 8 December 1958. http://www.time.com/time/magazine/article/0,9171,864488,00.html.

Time. "Regilded Gate." 4 September 1939. http://www.time.com/time/printout/0,8816,762541,00.html#.

Tucker, Margaret A. "Women with Cameras." *Popular Photography*, September 1943.

Turman, Judith Jenkins. "Austin and the New Deal." *Texas Cities and the Great Depression*. Austin: The Texas Memorial Museum, 1973.

U.S. Bureau of the Census. *Bryan, Brazos County, Texas, 1870*.

U.S. Bureau of the Census. *Census of Agriculture, 1940*.

U.S. Bureau of the Census. *Census of Mineral Industries, 1940*.

U.S. Bureau of the Census. *Occupation Statistics, 1930.*

U.S. Bureau of the Census. *Travis County, Texas, 1880.*

University of Texas. "Documents of the General Faculty: In Memoriam John Matthias Kuehne." http://www.utexas.edu/faculty/council/2000-2001/memorials/AMR/Kuehne/kuehne.pdf.

University of Texas, Department of Physics. *Catalogue Number Part VI: College of Arts & Sciences and School of Education, 1932-1933.*

University of Texas Daily Texan, 1932–26 February 1941.

VanGiezen, Robert, and Albert E. Schwenk. "Compensation From Before World War I Through the Great Depression." 2003. http://www.bls.gov/opub/cwc/cm20030124ar03p1.htm.

Waco, Tex. The Texas Collection, Baylor University.

White, Clarence. "Photography as a Profession for Women." *News-Bulletin of the Bureau of Vocational Information*, April 1924, 49-55.

White, Mrs. Clarence H. "Camera's Eye View of Careers." *Independent Woman*, February 1937.

Worley's General Directory of the City of Dallas, 1904–1905.

Writers' Program of the Work Projects Administration in the State of Texas. *Texas, a Guide to the Lone Star State.* New York: Hastings, 1940.

Yochelson, Bonnie. "Clarence H. White Reconsidered: An Alternative to the Modernist Aesthetic of Straight Photography." *Studies in Visual Communication* (Fall 1983), 26-44.

TEXAS IN THE 1930s

[1] Willard D. Morgan and Henry M. Lester, *Graphic Graflex Photography: The Master Book for the Larger Camera* (New York: Morgan & Lester, 1950).

[2] Rene West, "RE: Polly Smith research." Email to the author, 14 December 2006.

[3] Frank Watson to Whom it may concern, 23 October 1935, Dallas Historical Society, box 23.

[4] Henry Benge Crozier, "Ad Clubs Hear Theodore H. Price," *The Dallas Morning News*, 7 November 1923, pt. I, p. 1.

[5] "Personalities—W.H. Kittrell," Dallas Historical Society, box 107.

[6] Bradley R. Rice, "The Depression Comes to Taylor," in *Texas Cities and the Great Depression,* Robert Crawford Cotner (Austin: Texas Memorial Museum. 1973), 30.

[7] *Handbook of Texas Online*, s.v. "Dust Bowl," http://www.tsha.utexas.edu/handbook/online/articles/DD/ydd1.html (accessed 14 April 2007).

[8] Deut. 28: 24 in "Dust Clouds Bring Damage to Crops, Darkness to Texas," *The Dallas Morning News*, 12 April 1935, sec. I, p. 1.

[9] "Dallas Must Get Centennial, Chamber Committee Decides," *The Dallas Morning News*, 14 April 1934, sec. II, p. 1.

[10] Kenneth B. Ragsdale, *The Year America Discovered Texas: Centennial '36* (College Station, Tex.: Texas A&M, 1987), 49, 51, 54-55.

[11] "Dallas Shows Reasons Why This City Should Get Texas Centennial," *The Dallas Morning News*, 7 September 1934, sec. II, p.1.

[12] In Ragsdale, *America Discovered Texas*, 56.

[13] Ragsdale, *America Discovered Texas*, 58.

[14] "Personalities—W.H. Kittrell," n.d., Dallas Historical Society, box 107.

[15] Ibid.

[16] Ibid.

[17] Frank Watson, "The Time Factor," October 1935, Dallas Historical Society, box 23.

[18] Ibid.

[19] Watson to Cline, "Objectives," Dallas Historical Society.

[20] Frank Watson, "The Time Factor," Dallas Historical Society.

[21] Watson to Cline, "Objectives," Dallas Historical Society.

FAMILY IS EVERYTHING

[1] C.R. Smith, "The Spirit of the Pioneer." Austin History Center.

[2] Dorothy Smith, "Letters," *Time*, 8 December 1958. http://www.time.com (accessed 1 September 2007).

[3] Polly Smith to Dorothy Smith Walton, n.d.

[4] C.R. Smith, "The Spirit of the Pioneer." Austin History Center.

[5] Bureau of the Census, *Bryan, Brazos County, Texas, 1870.*

[6] *Galveston Weekly News*, 11 March 1875 and 12 November 1875. http://ftp.rootsweb.com.

[7] *Galveston Weekly News*. 29 March 1875. http://ftp.rootsweb.com.

[8] Victor Hotho, Photoarchivist at the State Preservation Board, Email message to author, 1 June 2007.

[9] "Little Misunderstanding," *Galveston Daily News*, 11 August 1874, p. 1. http://boards.ancestry.com.

[10] *Galveston Daily News*, 26 April 1875. http://ftp.rootsweb.com.

[11] *Handbook of Texas Online*, s.v. "Rockdale, Texas," http://www.tsha.utexas.edu/handbook/online/articles/RR/hfr8.html (accessed 15 March 2007).

[12] Research Division, Texas Legislative Council, *The Texas Capitol: A History of the Lone Star Statehouse* (Austin 1998), 20.

[13] Mike Fowler and Jack Maguire, *The Capitol Story: The Statehouse in Texas* (Austin: Eakin, 1988).

[14] *Fort Worth Democrat-Advance*, "Austin," 1 January 1882, p. 1.

[15] "The Texas Granite Edifice," *The Dallas Morning News*, 22 April 1888, p. 2.

[16] Mary Belle Batte, "History of Education In Milam County" (Master's thesis, Southwestern University, 1936). http://www.geocities.com/milamco/milam-858g.htm.

[17] Sam P. Harben to Gov. Pat M. Neff, 28 September 1920, The Texas Collection, Baylor University.

[18] Gail Muskavitch to Carla Smith, 5 July 1982.

[19] Muskavitch to Smith, 5 July 1982.

[20] State of California, death certificate of Alfred Burck.

[21] Bureau of the Census, *Travis County, Texas, 1880.*

[22] War Department, Adjutant General's Office, *Widow's Application for a Pension*, 27 April 1916, Texas State Archives.

[23] Milam County Heritage Preservation Society, *Matchless Milam: History of Milam County, Texas* (Milam County Heritage Preservation Society, 1984).

[24] *History of Texas, Together with a Biographical History of Milam, Williamson, Bastrop, Travis, Lee and Burleson Counties* (Chicago: Lewis, 1893), 323-324.

[25] Gail Muskavitch to Dorothy Walton and Burck Smith, 4 October 1981.

[26] *Widow's Application*, Texas State Archives.

[27] Milam County, *Matchless Milam.*

[28] *History of Texas,* 323-324.

[29] Wedding invitation of Roy Smith and Marion Burck.

[30] *Morrison & Fourmy's General Directory of the City of Waco*, 1898-99.

[31] *Worley's General Directory of the City of Dallas*, 1904.

[32] Muskavitch to Walton and Smith, 4 October 1981.

[33] Dorothy Smith Walton, "Copy of Resume of Family History," n.d.

[34] Muskavitch to Walton and Smith, 4 October 1981.

[35] Walton, "Resume of Family History."

[36] Walton, "Resume of Family History."

[37] "Death of Mrs. C.R. Smith," *Arkadelphia Southern Standard*, 8 January 1931.

[38] Burck Smith, "Continuation of Resume of History of the Smith Family."

[39] Gail Muskavitch, telephone interview with author, November 2006.

[40] Muskavitch, telephone interview, November 2006.

[41] Muskavitch, telephone interview, November 2006.

[42] "Many Lawyers will Serve as Census Supervisors," *The Dallas Morning News*, 26 October 1919, pt. 2, p. 11.

[43] "Census Supervisor Appointed," *The Dallas Morning News*, 8 August 1919, p. 5.

[44] Gail Muskavitch to Suzanne Huffman, 27 June 1995.

[45] Diana L. Magnuson, "Selection of Census Supervisors and Enumerators, 1890-1940," *NAPP: North Atlantic Population Porject,* Minnesota Population Center, University of Minnesota. http://www.nappdata.org (accessed 29 April 2007).

[46] "Census enumerators announced," *The Dallas Morning News*, 21 October 1919, p. 3.

[47] "More than 100 enumerators are needed for 1920 county census," *The Dallas Morning News*, 22 October 1920, p. 13.

[48] "Few applications filed for census enumerators," *The Dallas Morning News*, 23 October 1919, p. 5.

[49] "Pay for Enumerators of Census Increased," *The Dallas Morning News*, 5 December 1919, p. 12.

[50] "Census supervisors for Texas are announced," *The Dallas Morning News*, 6 August 1919, p. 2.

[51] James Morrow, "Nation's Greatest Inventory, the Census, will be Taken Beginning January 2, 1920," *The Dallas Morning News*, 7 December 1919, pt. 2, p. 3.

[52] Smith, "Continuation of Resume."

[53] Jno. Abney to Pat M. Neff, 24 September 1920, The Texas Collection, Baylor University.

[54] Rufus Hardy to Pat M. Neff, 13 October 1920, The Texas Collection, Baylor University.

[55] Abney to Neff, 24 September 1920, Baylor University.

[56] "Fort Worth to Wage Port of Entry Campaign," *The Dallas Morning News*, 2 December 1920, p. 15.

[57] Horton Porter to Pat M. Neff, 25 September 1920, The Texas Collection, Baylor University.

A HOME AT LAST

[1] *Austin City Directory*, 1924.

[2] Jack Alexander, "Just Call Me C.R.," *The Saturday Evening Post*, 1 February 1941.

[3] Smith, "Continuation of Resume."

[4] Austin High School *Comet*, 1925.

[5] Gail Muskavitch, letter to author, 3 August 1997.

[6] Austin High School *Comet*, 1924.

[7] *Austin City Directory*, 1929.

[8] Columbia University, "Early Punch Card Machines." http://www.columbia.edu/acis/history/oldpunch.html (accessed 24 March 2007).

[9] *Austin City Directory*, 1932-33.

[10] Doug Boyer and Bruce Carrell, "Information Technology Careers: Past, Present, and Future" (paper, University of Missouri, fall 2004). http://www.umsl.edu/divisions/business/mis/ITCareers.pdf (accessed 24 March 2007).

[11] University of Texas, transcript for Polly Smith.

[12] University of Texas, transcript for Polly Smith.

[13] University of Texas, "Documents of the General Faculty: In Memoriam John Matthias Kuehne." http://www.utexas.edu/faculty/council/2000-2001/memorials/AMR/Kuehne/kuehne.pdf (accessed 28 March 2007).

[14] University of Texas, *Catalogue Number Part VI: College of Arts & Sciences and School of Education, 1932-1933*, 94.

[15] "Dr. Kuehne Records Life on Colored Photographs," *Daily Texan*, 1932.

[16] Judith Jenkins Turman, "Austin and the New Deal," *Texas Cities and the Great Depression* (Austin: The Texas Memorial Museum, 1973), 190.

[17] Ibid., 189-207.

[18] Bonnie Yochelson, "Clarence H. White, Peaceful Warrior," in *Pictorialism Into Modernism: The Clarence H. White School of Photography*, ed. Marianne Fulton (New York: Rizzoli, 1996), 26-28.

[19] Kathleen A. Erwin, "'Photography of the Better Type:' The Teaching of Clarence H. White," in *Pictorialism Into Modernism: The Clarence H. White School of Photography*, ed. Marianne Fulton (New York: Rizzoli, 1996), 140.

[20] Ruth L. Bohan, "Weber, Max," *Grove Art Online*, Oxford University Press. http://www.groveart.com/ (accessed 1 April 2007).

[21] Erwin, "'Photography of the Better Type,'" *Pictorialism Into Modernism*, 154.

[22] Ibid., 162.

[23] Bonnie Yochelson, "Clarence H. White Reconsidered: An Alternative to the Modernist Aesthetic of Straight Photography." *Studies in Visual Communication* 9 (fall 1983): 26-44.

[24] Clarence H. White School of Photography, in Erwin, "'Photography of the Better Type,'" *Pictorialism Into Modernism*, 152.

[25] Ibid., 186.

[26] *Austin City Directory*, 1935.

THE MYTHS OF WOMAN PHOTOGRAPHERS AND TEXAS

[1] Clarence H. White, "Photography as a Profession for Women," *News-Bulletin of the Bureau of Vocational Information* (April 1924): 49-55.

[2] Mildred Stagg, "Woman's Place in Photography," *Popular Photography* 5 (September 1939): 78.

[3] Frances Benjamin Johnston, "What a Woman Can Do with a Camera," *The Ladies' Home Journal* (14 September 1897): 6.

[4] Ibid.

[5] Erwin, "'Photography of the Better Type,'" *Pictorialism Into Modernism*, 140.

[6] White, "Photography as a Profession for Women," *News-Bulletin*, 49-55.

[7] Peter E. Palmquist, ed., *Camera Fiends & Kodak Girls* (New York: Midmarch, 1989), 35.

[8] Mrs. Clarence H. White, "Camera's Eye View of Careers," *Independent Woman* (February 1937): 46.

[9] Stagg, "Women's Place," *Popular Photography*, 26.

[10] Peter E. Palmquist, "Essays," *Women Artists of the American West*.
 http://www.cla.purdue.edu/WAAW/palmquist/Essays.htm (accessed 3 May 2007).

[11] Bureau of the Census, *Occupation Statistics*, 1930.

[12] Don Graham, *Cowboys and Cadillacs* (Austin: Texas Monthly Press, 1983), 9.

[13] Ibid., 21.

[14] Ibid., 19.

[15] Joseph Leach, *The Typical Texan: Biography of an American Myth* (Dallas: Southern Methodist University, 1952), 117-118.

[16] Rose Lee Martin, "Lone Star State Still Goes It Alone," *New York Times*, 7 June 1936, p. 111.

[17] Ibid.

[18] Ibid.

[19] Frank Watson to Walter Cline, n.d., Dallas Historical Society, box 23.

[20] Bonnie Langley to Peggy Riddle, 11 November 1984. Dallas Historical Society, Bill Langley file.

[21] Reginald William Langley, WWI draft registration card. http://ancestry.com (accessed 3 May 2007).

[22] Langley to Riddle. 11 November 1984.

[23] Judy Anderton, "Bill Langley," unknown magazine, Dallas Historical Society, box "Architects and Others."

[24] William Langley to Frank J. Purcell, 11 September 1935, Dallas Historical Society, box 73.

[25] Langley to Riddle. 11 November 1984.

[26] "Texas Honors Former U.S. Vice-President," *The Dallas Morning News*, 2 January 1936, sec. 1, p. 2.

[27] Douglas Silver to C.M. Vandeburg. 3 April 1936, Dallas Historical Society, box 113.

[28] Jim Crane, Dallas Historical Society, box 113. Another stunt idea, which was never acted on, was that of letting a load of Texas jackrabbits "accidentally" get loose in the middle of Manhattan rush hour.

[29] Frank Watson, October 1935, Dallas Historical Society, box 23.

[30] Robert VanGiezen and Albert E. Schwenk, "Compensation From Before World War I Through the Great Depression," 2003. http://www.bls.gov/opub/cwc/cm20030124ar03p1.htm (accesssed 27 May 2007).

[31] W.M. Herzog to Betty Bauersfeld, 31 March 1936, Dallas Historical Society, box 33.

[32] James Frank Dobie, *Tales of Old-Time Texas* (Austin: University of Texas, 1984), 325.

[33] W.H. Kittrell to R.W. Knight, 24 June 1935, Dallas Historical Society, box 73.

[34] Muskavitch, letter to author, 3 August 1997.

[35] Polly Smith, 5 October 1935, Dallas Historical Society, box 23.

[36] Ibid.

[37] C.M. Vandeburg to Doug Silver, 25 June 1936, Dallas Historical Society, box 113.

TRAVELING TEXAS

[1] C.M. Vandeburg to Polly Smith, 8 October 1935, Dallas Historical Society, box 23.

[2] "Regilded Gate," *Time* (4 September 1939). http://www.time.com/time/printout/0,8816,762541,00.html# (accessed 27 May 2007).

[3] Pat Stephenson, "Young Man with the Answer," *Los Angeles Times Sunday Magazine* (8 January 1939): 5.

[4] Ibid.

[5] "Photographic Assignment Sheet for Polly Smith," Dallas Historical Society, box 151.

[6] Gail Muskavitch, letter to author, 18 June 1994.

[7] "All America is Invited to Visit Texas Centennial Celebrations," (brochure), Dallas Historical Society, box 160.

[8] Penny Beaumont, *et al*. "Early Highway Development in Texas," *From Anywhere to Everywhere: The Development of the Interstate Highway System in Texas* (Bryan, Tex.: Texas Transportation Institute, Texas A&M University). http://tti.tamu.edu/interstate_anniversary/white_paper/ (accessed 5 May 2007).

[9] "Get Ready for the Centennial—Tidy Up Texas," *The Dallas Morning News*, 21 April 1935, sec. III, p. 17.

[10] William M. Thornton, "Highways Leading to Dallas to be Put in Best Shape for Visitors to Centennial," *The Dallas Morning News*, 4 April 1936, sec. I, p. 3.

[11] "60-Mile Highway Speed Limit Asked by Allred Safety Group in Drastic Traffic Law Changes," *The Dallas Morning News*, 5 June 1938, sec. I, p. 1.

[12] Writers' Program of the Work Projects Administration in the State of Texas, *Texas, A Guide to the Lone Star State* (New York: Hastings, 1940), xxiii.

[13] Willard D. Morgan and Henry M. Lester. *Graphic Graflex Photography: The Master Book for the Larger Camera* (New York: Morgan & Lester, 1950), p. 6.

[14] C.M. Vandeburg to Polly Smith, 15 October 1935, Dallas Historical Society, box 23.

[15] Ibid.

[16] Ibid.

[17] Texas Centennial Central Exposition Promotion Department, "Receipt for Photographs," 7 April 1936, Dallas Historical Society, box 23.

[18] Texas Centennial Central Exposition Promotion Department, "Receipt for Photographs," 30 March 1936, Dallas Historical Society, box 23.

[19] Texas Centennial Central Exposition Promotion Department, "Receipt for Photographs," n.d., Dallas Historical Society, box 23.

[20] Statement of Traveling Expenses, Dallas Historical Society, box 23.

[21] Bureau of the Census, *Census of Agriculture, 1940.*

[22] Marion B. Smith to C.M. Vandeburg, 18 December 1935, Dallas Historical Society, box 151.

[23] Bureau of the Census, *Census of Mineral Industries, 1940.*

[24] "Photographic Assignment Sheet for Polly Smith," Dallas Historical Society, box 151.

[25] Jonathan B. Hook, *The Alabama-Coushatta Indians* (College Station, Tex.: Texas A&M, 1997), 54-55.

[26] Ragsdale, *America Discovered Texas*, 30.

[27] Alyce Siemens, "Girl About Town," *The Dallas Morning News*, 24 July 1936, sec. I, p. 12.

[28] William Langley to Philip Fox, 19 February 1936, Dallas Historical Society, box: Architects and Others.

[29] Philip Fox to Frank Watson, 19 February 1936, Dallas Historical Society, box: Architects and Others.

[30] Gail Muskavitch, letter to author, 24 November 1997.

[31] Polly Smith to Jacque Lansdale, n.d., Dallas Historical Society, box 23.

[32] Smith to Lansdale, n.d., Dallas Historical Society, box 23.

[33] Frank Watson to Polly Smith, 15 February 1936, Dallas Historical Society, box 23.

[34] Polly Smith to Frank Watson, 13 March 1936, Dallas Historical Society, box 23.

[35] A.R. Crow to Polly Smith, 4 March 1936, Dallas Historical Society, box 23.

[36] Polly Smith to A.R. Crow, n.d., Dallas Historical Society, box 23.

[37] Polly Smith to A.R. Crow, 19 March 1936, Dallas Historical Society, box 79.

[38] Smith to Lansdale, n.d., Dallas Historical Society, box 23.

[39] Willard D. Morgan and Henry M. Lester, *Graphic Graflex Photography* (New York: Morgan & Lester, 1943), 349.

[40] William M. Danner, "An Air-Conditioned Darkroom," in *Photographic Hints & Gadgets* (Boston: American Photographic Publishing, 1937), 112-114.

[41] Muskavitch, letter to author, 18 June 1994.

[42] Smith to Watson, 13 March 1936, Dallas Historical Society, box 23.

[43] Smith to Crow, 19 March 1936, Dallas Historical Society, box 79.

[44] Frank Watson, "Budget Revision," October 1935, Dallas Historical Society, box 23.

[45] Russ Gudgeon to C.M. Vandeburg, 14 February 1936, Dallas Historical Society, box 112.

[46] Russ Gudgeon to C.M. Vandeburg. 15 February 1936, Dallas Historical Society, box 112.

[47] Gudgeon to Vandeburg, 15 February 1936, Dallas Historical Society, box 112.

[48] C.M. Vandeburg, telegram to Frank Watson, n.d., Dallas Historical Society, box 23.

[49] C.M. Vandeburg to Doug Silver, 1 April 1936, Dallas Historical Society, box 113.

[50] Irvin S. Taubkin, "Bluebonnet Seen as Fashion Rage for this Season," *The Dallas Morning News*, 20 March 1936, sec. I, p. 4.

[51] Ibid.

[52] Texas Centennial Central Exposition Promotion Department, "Receipt for Photographs," 10 April 1936, Dallas Historical Society, box 23.

[53] Texas Centennial Central Exposition Promotion Department, "Receipt for Photographs," 7 April 1936, Dallas Historical Society, box 23.

[54] Receipt of Photos from Polly Smith, 17 April 1936, Dallas Historical Society, box 23.

I HAVE NEVER BEEN SOLD ON A CAREER

[1] "World Seeks Information About Texas Centennial," *The Austin American*, 26 February 1936, p. 10.

[2] "Interest Found at Fever Pitch Over Centennial," *The Dallas Morning News*, 4 May 1936, sec. II, p. 8.

3 Gail Muskavitch to Suzanne Huffman, 12 June 1995.

4 "Chain Pickup of Centennial Opening to Lead Radio Week," *The Dallas Morning News*, 31 May 1936, sec. II, p. 5.

5 C.M. Vandeburg to Doug Silver, 25 June 1936, Dallas Historical Society, box 113.

6 Peggy Riddle and Sarah Hunter, *State of Texas Building*, (MSS), Dallas Historical Society, box: Texas Centennial-Art.

7 Tom Simmons, "Massive, Spacious Edifice, Hall of State, Adequately Reflects Texas' Greatness," *The Dallas Morning News*, 21 September 1936, sec. II, p. 1.

8 Deborah Smith, Email to author, 28 February 2007.

9 "Picture Section," *The Dallas Morning News*, 9 April 1939, p. 6.

10 "Faces of the Month," *Texas Parade* 3, no. 7 (December 1938): 28.

11 "Ladies' Line-up," *Time*, 15 February 1937. http://www.time.com/time/magazine/article/0,9171,882704,00.html (accessed 11 May 2007).

12 Doug Silver to C.M. Vandeburg, 22 April 1936, Dallas Historical Society, box 113.

13 Taubkin, "Bluebonnet," *The Dallas Morning News*, 20 March 1936.

14 James Crane to C.M. Vandeburg, 14 January 1936, Dallas Historical Society, box 151.

15 C.M. Vandeburg to E. Dick, 2 April 1936, Dallas Historical Society, box 86.

16 Gail Muskavitch, letter to author, 27 July 1997.

17 Polly Smith to Dorothy Walton, n.d.

18 "Maj. Bill Long: Aviation's Tall Texan," *Business/Commercial Aviation* (May 1961): 77.

19 Dotty Griffith, "Pioneer Pilot's a Living Legend," *Dallas Morning News*, 19 September 1975, sec. D, p. 1.

20 Dallas Aviation School and Air College, in *Flying and Popular Aviation* (September 1940): 9.

21 Stephenson, "Young Man with the Answer," *Los Angeles Times Sunday Magazine*, 20.

22 Ray Osborne, "1941 Steers Close Brilliant Career, Crush Oregon U, 71-7," *The Dallas Morning News*, 7 December 1941, sec. 4, p. 1.

23 Lloyd Price, "Pacifists Scarce after Bombs Drop on Hawaii," *The Dallas Morning News*, 8 December 1941, sec. II, p.1.

24 Ibid.

25 Ibid.

26 "Japan is Warned Texas Longhorns Might Oregon It," *The Dallas Morning News*, 9 December 1941, sec. I, p. 8.

27 "Seven-Day Defense Production, Antistrike Agreement Sought," *The Dallas Morning News*, 9 December 1941, sec. I, p. 1.

28 "Four Girls From *(sic)* Liberty Belles to Aid War Effort," *The Dallas Morning News*, 13 December 1941, sec. I, p. 12.

29 Ibid.

30 C.R. Smith Museum, "Cyrus Rowlett Smith Biography." http://www.crsmithmuseum.org/AAhistory/AA_frameset.htm (accessed 27 May 2007).

31 Donald H. Agnew and William A. Kinney, "American Wings Soar Around the World," *National Geographic* (July 1943): 57.

32 Ibid., 77.

33 "Cyrus Rowlett Smith Biography." http://www.crsmithmuseum.org/AAhistory/AA_frameset.htm.

34 *Handbook of Texas Online*, s.v. "Bergstrom Air Force Base," http://www.tsha.utexas.edu/handbook/online/articles/BB/qbb2.html (accessed 21 April 2007).

35 "Mother of Three in Service Does War Work at Home," *Austin American Statesman*, 27 November 1942.

36 Ibid.

37 Jean Begeman, "Others Praise Mother of 3 Servicemen," *Austin American-Statesman*, 18 February 1945, p. 10.

38 "Air Line President's Mother, Friend of Many GI's, Dies," *The Dallas Morning News*, 26 January 1950, sec. 1, p. 7.

39 Muskavitch, letter to author, 27 July 1997.

40 Gail Muskavitch to Flo Prichard and Dorothy Walton, 2 April 1951.

41 Muskavitch, letter to author, 3 August 1997.

42 Muskavitch, letter to author, 26 October 1997.

43 Polly Smith to Dorothy Walton (unnamed), n.d.

44 Gail Muskavitch, telephone interview with author, 12 January 2007.